Bande à part
On Independent Art Institutions

STATEMENT

QUESTIONNAIRE

ESSAY

Roundtable Introduction

Rhea Dall

Hey, Prem and Chris—I would like to set off our introductory conversation about this book by focusing on one of the initial ideas behind it, namely whether the range of voices could become a kind of toolbox, addressing different site-specific and circumstantial conditions and rationales behind new art spaces.

One of our shared questions behind this endeavor was how (and why) artists and curators continue to initiate their own institutions and exhibit outside the logics of established exhibition arenas, sparking an array of unconventional, counter- or para-forums whose reactions to the "ordinary" museum or Kunsthalle model span from straightforward anarchist refusal to tinkering with institutional habits. It's a field we've all been participating in and talking about for years from different perspectives.

The call for other kinds of institutions is nothing new. A short-circuit lineage could trace this drive back to the French artist Gustave Courbet, who staged his own exhibition in Paris in 1855, with artworks that the Salon, famously, refused to show. And there are numerous publications made in this regard as well.[1] Yet comprehensive mapping of these worldwide and sprawling initiatives is scarce. This lack could probably be explained by perpetual underfunding, as organizations in this field are frequently left with few resources for chronicling, and by the fact that such art spaces are, in essence, often diffusely and intentionally snowballing under the radar and into new functions, resisting being summed up in a numerical catalogue raisonné. Novel initiatives that call for the inclusion of alternative methods or voices and expand the scope of the so-called art world do not easily lend themselves to cartographies. In that sense this publication is no exception. We're not mapping a field. Rather, what we're creating is a testimony to a network of interlocutors across the world (from approximately 2010–20), each harboring

very different geographical urgencies—from *Sørfinnest Skole* in the North of Norway to RAW Material Company in Dakar; from Lulu in the heart of Mexico City to Asakusa in central Tokyo.

We are participating in an already flourishing conversation in a field that could be characterized most prominently as differing from scripted canonization or linearity. In these muddy waters, our modest proposal is to offer some insights into the machinery and bring together a toolbox made of a set of examples of self-organized art institutions—a buffet or smorgasbord of different concrete setups, hopefully functioning as inspiration and as testimony to initiatives we've followed while they took place.

In that sense, this publication aims at connecting the "hows" and "whats" to the "whys"—the first often being relegated to the back seat. It's generally only the conceptual framework of an exhibition space that's given attention (from a "critical" perspective), not the murky and meticulous work of actually constructing such a weird entity as an art institution (spoken of by someone on the inside, in the engine room) which, at least to my mind, is paramount to understanding how any new institutional initiative actually comes about.

To stay with this idea of the toolbox for a second: what are your thoughts on this idea and how it addresses the many different, site-specific, and circumstantial rationales of the different institutions?

Chris Sharp

Thanks for your intro, Rhea. You cover a lot of territory which, for me, goes back to 2015 when I co-organized with Christian Kobald a closed-door meeting at ARCOmadrid, which featured a lot of people involved in *Bande à part,* such as Fernanda Brenner from Pivô, João Mourão and Luís Silva from Kunsthalle Lissabon, and, of course, yourself. At the time, my motivations were quite simple, and even a bit selfish: having opened Lulu a little less than two years before, and therefore still pretty wet behind the ears, I was anxious to learn from other peoples' experience, not only how to run this kind of space, but I also wanted to engage in some kind of collective reflection about what such a space could be and do. This helped me enter a community of like-minded individuals who were, in many cases, modestly recreating a new model, but each

and everyone of them, in their own way and for their own reasons. This original motivation remained a big part of the impetus for me in co-organizing the *Bande à part* conference.

Another aspect that interested me was more historical—and that was, why now? What specific social, economic, historical, and technological circumstances had led to the mushrooming of this kind of small-scale, self-initiated if ambiguous take on the institution? For although there have been artist-run spaces, and in some cases institutions for a while, the proliferation and level of professionalism of precisely these kinds of spaces since the early 2010s or so, seemed to be something new. Was this phenomenon responding to some kind of objective necessity? Was it, with the aid of certain historical developments, filling in perceived gaps in the local and international art ecosystem and discourse? Or was it somehow merely self-indulgent?

The questionnaires published in this book dive into a lot of these questions and more. Virtually every contributor speaks about some kind of deficiency in their local scenes or art in general which they sought to redress. Some go on to address the conditions which permitted the formation of this kind of space; 1857, for instance, mentions cheap air travel. Such a detail might seem trivial, but the extent to which budget airlines, at least in pre-pandemic Europe, contributed to the mobility of artists and professionals over the last decade cannot be underestimated. This is exactly the kind of development, along with the internet, that helped many of us seize and control the means of production, which, formerly, might have been only available to large-scale galleries and institutions.

Prem Krishnamurthy

Budget air travel is a great point; do you remember when we used to still travel all the time? We, too, first talked about some of these topics on an art fair panel on hybrid art spaces organized by Mari Spirito in 2015. This, and later such conversations—among them the 11th Gwangju Biennale Forum, organized by Binna Choi and Maria Lind in 2016, which brought together around 100 spaces from around the world for a multi-day discussion and small workshops[2]—were tremendously helpful in providing a sense of how the project I was undertaking in NYC connected to other

approaches from around the world—and also in helping me feel not alone in the insanity of starting a space!

I do wonder how much of the proliferation and profession-alization of these "upstart" "alternative" institutions happened as a result of the proliferation of biennials, the expanding art market, and the apparently smooth networks of the 2010s. Seen from the remove of 2021, I start to think about how quixotic the goal of creating a space with an alternative model might have been within the increasing homogenization and financialization of art in that era. This is not to discount the specificity and local character of P! and other institutions, a productive friction against the backdrop of prevailing ideas around a "globalized" art world.

What ended up distinguishing *Bande à part* for me as a conference and gathering was the comparatively intimate scale of the project, the acknowledged interconnections of its partici-pants, and the intention to publish the conference's findings not as a hagiographic compilation, but rather as a set of tools for others. More and more these days, as a teacher and curator and designer, I want to "open up the hood" and give people as much access to the "how-to" as possible, so that these fields don't remain as inaccessible and elite. Personally, I came to understand the project as a highly subjective snapshot of an extended "scene" or context, within which the three of us played a greater or lesser role.

One advantage of our own deeply embedded engagement with many of the other participants is that we were able to ask each of these spaces (as well as of ourselves) the kinds of ques-tions that are usually left unspoken in more polite art historical or "institutional" company: How did you *really* work, how much money did you make (or lose), how was the space supported, what failed, what did you learn, what are you doing next? For the most part, I feel that we received honest responses and reflections. Seen from the outside, the relative homogeneity between many of the institutions could appear as an oversight, but their prior inter-sections also allowed for a productive discussion.

What strikes me now is the spaces' essential ephemer-ality; how many of them will still exist by the time of this book's publication? I know our three spaces have all either closed or transitioned in some significant way. Perhaps the fact that many of the spaces were already "expiring" or in periods of institutional

transition in 2019, during our conference, allowed for the degree of candor that participants brought to their written texts and presentations. Hopefully this can also infuse this publication and make it a useful seedbank for future practitioners.

CS

I wanted to jump in and respond to something you point out, and that is the surfeit of symposia, discussions, etc., around the self-initiated space in the 2010s, including our conference and this subsequent book at hand. Looking back, there were indeed times when this kind of self-consciousness could seem self-congratulatory, but I wonder if, by the same token, this self-consciousness was not also tied into a kind of accountability. For instance, most, if not all of the spaces involved in *Bande à part* were (or still are) set up in unconventional ways, and therefore many of them did (or do) not have boards. I think it's possible to look at these discussions as substitutes, to a certain degree, for boards, in which we all functioned as each other's dispersed board, becoming accountable to one another, as well as providing advice in the capacity of unofficial advisors to one another.

RD

Commenting on the question of the self-congratulatory, I cannot help but think about how Thomas Boutoux, co-founder of castillo/ corrales, mentions in his text that, while being almost always "self-reflective," small-scale institutions and their experiments are always in danger of becoming "self-satisfied" or, even stronger, "self-obsessed." I really like this comment since I think it adds perspective. The intimacy of many of us having spent years talking to each other borders on the self-absorbed. Yet I wonder which kind of resourcefulness is needed to assume the utopian conquest of actually setting up a shop on your own. Beyond the basics of financial means (if sparse) and an infrastructure, there is a kind of trust from a community, from friends, and a surrounding sounding board needed—as you both touch upon.

A consistent note throughout these texts is that most initiatives talk about how they are constituted communally rather than independently—through communal relations, groups of friends. This is what Max Pitegoff and Calla Henkel in the

description of their Berlin-based initiative New Theater call "a shared language developed between collaborators," and it's what RAW Material Company call on when saying "the relationships between humans are the bedrock of what we do."

Now, I would like to think that if the conference in itself was an intimate affair of people who over the years have passed the point of needing to create a space of their own, who've gained some relative visibility, and either dissolved their experimental or ephemeral initiatives or created new ones, then this publication—in all its backroom breakdown directness—can trigger entirely new seating arrangements, different tables, new models, novel communities, running against the naturalization of structural standards. This might, in turn, be a comment on how some of our own experiments—or some of the ones described in this book—have coalesced. Or how the repetition of an experiment runs the risk of becoming a new kind of conservatism; turning into new standards. In that sense I hope this publication could function as an incentive, in an ongoing exchange of institutional "hows" and "for whoms"—a call for new gangs or new "bandes (à part)," even if microscopic or temporal, dreaming up or working out alternate ways of archiving, convening, producing, inclusion, and making artistic and cultural matter accessible, as part of a greater discussion around who sets the scene and from which perspective.

Prem/Chris, I wonder if you want to comment on, in a broader sense, how this toolbox of institutional efforts can be of use?

PK

To paraphrase podcasting guru Krista Tippett: the more specific a person's story can be told, the more generally applicable to others it can become. What I mean to say by that is: moving beyond our self-critique and consideration of what we overlooked (which, I think, is useful self-reflection), the value of the publication is really in how specific it's able to become. How much we're able to unpack and bring the contributors/participants along on this as well—our own situations and what allowed us and others to make the spaces that we did. I'm usually wary of "modeling" when it's about people claiming that there's any template or path that others might be able to follow, but more

compelled by "modeling" when used in the scientific sense of trying to account for and describe as many variables and conditions of a given context as possible.

The part that most engages me at the moment—but which is also usually the hardest to describe or document—is the collaborative and community aspects of these spaces. Chris Kraus highlighted this in her contribution to this book. There is a key low-key, quotidian, interpersonal element to running an art space. I've heard a lot of people over the years talk about "conviviality" or "being a good host" as essential to this kind of cultural work, but what do those notions mean to different people? The specific kinds of social structures and skills that allow for making an independent space are usually left unarticulated, which in my experience can mean that they are only accessible for folks who already are familiar with or conform to some unspoken set of perceived norms or defaults.

In my recent teaching across contexts (whether design, art, curatorial), I've started to explicitly teach and test out relational tools, such as formats for active listening, empathic feedback, small-group discussions, and more, as well as naming and discussing the kind of power dynamics at play. Some of this comes from my dialogue with practices like Microsolidarity (microsolidarity.cc), a kind of open-source compendium of different approaches to mutual care and exchange within small groups. Such organizing, facilitation, and awareness tools are essential to being effective in almost any collaborative, creative pursuit, yet they are rarely specifically taught in school.

Our approach to the publication as a structured questionnaire (and the design of the publication to emphasize these questions and responses) hopefully allows for reading across the different spaces comparatively. This was the format that we developed in the lead-up to the original conference as well; it relates to some of the books, which I help edit, that Paper Monument has published on art and etiquette, art assignments, and more. In organizing the conference, we shared the responses among the participants in advance of the gathering, which gave us a good shared starting point for discussions.

During the pandemic, what's become much clearer to me is that art exists primarily as a mode of communing with

others—the pleasure and productive friction of art can open up the possibility for unexpected interactions and encounters. Yet within this optimistic view, there's always the lurking question of who is actually being reached by contemporary art and what kinds of differences are allowed to exist within this context. Being transparent about the rules of engagement is a key part, I think, if we want to expand whom we want to welcome, and into what.

CS

To respond to your toolbox question above, Rhea, I think one thing that's clear for a lot of spaces included in this publication is the relative lack of prior experience in running a space. Pretty much everyone involved just did it, in some cases, in spite of everything, and learned on the job—I know I did. That said, I am hoping that this book can help give a new art space founder some indications of how to go about (or not about) creating the kind of space they want to create, in terms of identity, thoughtfulness, and funding, among others.

Rhea Dall, Prem Krishnamurthy, Chris Sharp

1 In recent decades, independent institutions as well as publica-tions, lectures, conferences, and even associations of and about such self-organized initiatives have mushroomed. In the early 2010s a number of anthologies were published, including the sociologically framed *Institutional Attitudes: Instituting Art in a Flat World* (2013); the historical mapping of (Western) initiatives in the 1960s and '70s, *Artist-Run Spaces* (2011); the North American-focused anthology *Institutions by Artists* (2012); and the publication *Self-Organised* (2013), while a later, important addition to the question of artistic curation is the 2017 anthology *The Artist as Curator* (Milan: Mousse, 2017, ed. Elena Filipovic).

2 Although the planned second catalogue for the Biennale was never published, my own contribution to that forum was a co-written speculative proposal for a graveyard of small, independent art institutions and their archives. This fictional "Archives of Institutional Memory" enjoyed an extended lifetime through the independent art space 019 in Ghent, Belgium, and informed their subsequent institutional initiative, the Kunsthal Gent.

1857
Stian Eide Kluge
& Steffen Håndlykken

Just like art itself, exhibitions are easy, a lot of fun, and anyone can make them. That was our motivation for opening 1857 in 2010. Of course, none of these statements are strictly true, but they propelled us into action. As recent graduates of the then-recently-defunct Institute of Color of the Oslo Academy of Art, we were eager to make Oslo, a relative backwater of international art, a little more interesting to ourselves and our peers. After having to move out of our shared studio, we decided to look for a new workspace that could be made accessible to the public, and where we could invite artists from outside of Norway to show their work. In the industrial lumberyard space that became the venue for 1857, we got more than we bargained for, and in addition to the extra cubic meters we scaled up production and presentation.

STATEMENT

Even before locating our kunsthalle-sized space, we had decided to conform to the typical mode of address for an institution, such as logo, press releases, a website, posters, opening hours, and street access, while also finding ways to infuse all of these elements with artistic concerns. Our close collaboration with designer Ian Brown helped us identify and slyly subvert our various formats of presentation, as did constant production assistance from Petter Ballo, serious bartending from Pablo Castro, assistance and pastry management from Paulina Stroynowska, and when Jenny Kinge later joined the team, she brought actual gallery experience. This, of course, was in addition to countless other friends and willing (or unwilling) collaborators, including a paint sponsor, transportation, scaffolding services, bookkeeping, office sharing, a brief car park operation, location scouts, and, on one memorable occasion, Oslo's longest baguette. While a touch of eccentricity is commonplace in the art world, at 1857 a menagerie spirit pervaded—and that is without even mentioning the artists.

The exhibition program of 1857 was a response to the space and to the artists we invited. Group shows sprang from the crumbling concrete walls, ceiling, and even the rooftop, and gave free rein to our experiments with "exhibition elements" and non-interpretative communication. Even solo shows were partly produced on-site, introducing local flavor, collaboration, and surprises for everyone involved. If there was a sense of direction to

the program, it was mostly due to the constant input from visiting artists, who would offer suggestions, provide contacts, contexts, and even gossip, or simply leave their ideas behind for us to steal.

Stian Eide Kluge & Steffen Håndlykken

Artists and artwork

It's hard to answer this in a nutshell. Much of the production of both artworks and exhibitions happened on-site in Oslo as a way to save on international shipping, but also because we wanted to be closely involved in the artists' processes. Some shows were very idea-driven, with artworks presented as "clutter" that hindered movement around the space. We always wanted to include an element of doubt in the exhibitions, to encourage the audience to think about the what and where (and sometimes even the why and how) of an artwork.

The exhibition space

It's important to know that our big concrete no-frills lumberyard in Grønland had a small storefront with an orange, floral linoleum floor; flowers became an important, if somewhat whimsical, subtext to how we presented ourselves. As artists organizing other artists' shows, the idiosyncrasies of our infrastructure became a primary esthetic consideration. *Drop Handkerchief Backdrop,* one of our earliest shows, took modern dental care as its model and dealt with the relationship between signed and unsigned art products with an almost scientific rigor. It featured works by Vanessa Billy, Georges Braque, David Keating, and Christian Tonner. The introduction to the show functioned like a metaphor for our own thinking about our space and reads as follows:

Until the middle of the last century it was not known what actually caused cavities in teeth. In Sweden it was a widespread problem, and in the 1940s as many as 99.9 % of the military conscripts had cavities. Though it was suspected that sugar played an important role, it was not yet scientifically confirmed.

As a countermeasure the government established The National Dental Service in 1945, and a set of experiments were initiated to root out any uncertainty. The location was Vipeholm Mental Hospital, housing several hundred patients who were to become part of the largest human experiment ever conducted in Sweden. The key element was to replace their regular meals with candy. Over the

course of several years the patients were fed copious
amounts of candy and caramel, and some were even
allowed and encouraged to eat as much as they wanted at
any time of the day.

The experiment was a huge success, and eventually
led to a full understanding of the effect of sugar on teeth.
Furthermore it prompted a concise formula of the
necessary elements in the formation of dental caries,
namely the inclusion of:

– Sugar
– Bacteria
– Time
– Teeth

By removing any of these four components you will not
form cavities. (Cavities are usually understood as
negative space, but are in reality soft spots on the teeth.)

Similarly, for any art space you need four components.

Site and geography

1857 came about through a combination of local circumstances:
the patchwork urban development of Oslo's downtown area
and the heritage restrictions for historic buildings, a new public
funding initiative for artist-run spaces, an established scene
of artist-run experiments, cheap air travel and expensive ground
transport, a dearth of worthwhile shows in the established
institutions, and ambitious professional visitor programs by both
state- and city-supported institutions. And while the exhibitions
did not directly address our vibrant, multi-ethnic, downtown
neighborhood Grønland, it was clear our days were numbered
when a Starbucks coffee shop opened on our corner.

International context

Our primary motivation for opening a project space was to connect to artists and audiences outside of the, at times, insular art scene in Oslo. 2010 is a lifetime ago, and while we were careful to document our shows from the start, the voracious appetite for online installation views that has become a defining feature of recent art was only just emerging. While 1857 got a lot of attention from international, online viewers, few of them found their way into the physical exhibition space.

Audience / Community

1857 had a small primary audience of artists and art professionals in Oslo, who would often develop into a sort of community. Our exhibitions were open to the general public, and we did get some mainstream press coverage, but it was still somewhat of a rarity when someone we didn't know showed up to see the exhibition.

Voice / Communications / Press

We developed a particular written voice with which to provide an interface with the artworks on view. We eventually adopted some house rules for writing about exhibitions—for instance, we banned writing visual descriptions of the exhibitions as we felt that was redundant given that the visitor in the space could see it with their own eyes. In the run-up to our very first show our designer, who had never heard of a checklist before, added a prominent ✓ to it, which then became a lasting, quirky feature on our lists.

Design / Online presence

Through our close collaboration with designers Eriksen/Brown we developed a strong visual identity for 1857. We also wanted the design to be responsive to the exhibitions and the rest of our operation, and share the creative agency as much as possible. For each exhibition poster the designers would offer a typographical or printed version of the show's main ideas. This led to some great design, but the collaboration was also useful in verbalizing ideas for exhibitions that often stemmed from intuition, glimmers of unrealized installations, or from some itch in a particularly hard-to-get-at spot.

Publishing

While we printed posters and ephemera for nearly every show, we've made only one book (so far): a monograph on Ad de Jong. The publication depended heavily on the research of the external co-curator, Fleur van Muiswinkel, who introduced us to the artist, but it was a typical in-house production with design by Eriksen/Brown and a cover that doubled as an exhibition poster. Once back from the presses it flew off the shelves, but lacking a conscientious distributor, we certainly didn't see any profits from it.

Economy / Resources

Since its first year of operation, 1857 received funding from the Norwegian Arts Council. They aimed to professionalize artist-run spaces in Norway, and therefore awarded us with 20% of the funding that a comparable public institution would receive. While this grant was stable and relatively unconstrained, the artist stipends we were able to get for ourselves and then re-invested in the space in the early years were the most decisive factor, and the most vital contribution throughout was the free labor that our friends and family (and we ourselves) poured into the project.

Duration / Perseverance

Our original objective, to make the local art community more interesting, is never-ending (if not slightly self-fulfilling, too). Nevertheless, there was no reason for 1857 to go on indefinitely, and we will each most definitely find new ways to fulfill our most pressing tasks.

Three of us ran 1857 (Jenny, Stian, and Steffen) along with a bunch of other vital contributors. When we lost our Grønland site due to gentrification, we set out to find a new space. All of a sudden, each of us had limitless possibilities we, as individuals, wanted to pursue. The framework of our original space served a least common denominator of sorts. To make the project go on became a project in its own right, and that was never the point.

Key artists

A key motivation for us was to establish close working relation-ships with artists whose practices we found interesting, inspiring,

or in some way mystifying. As we made more exhibitions, previous exhibitors became invaluable partners in developing new ideas; they also provided us with connections (as well as intel!) and grammar help (English and other languages). Among our greatest influences were Allison Katz, Ad de Jong, Darren Bader, Nancy Lupo, and Oa4s. We "locked" Allison up in a tower to produce eight new monumental paintings in a single week. Ad's resolve to "Help Young Worlds" struck a chord with our own endeavor. Our back-and-forth with Darren about the meaning and logistics of his work continues to this day. Nancy's thorough, and thoroughly material, practice can only be described as "genius" and as perpetually "ongoing." Mikey and Temra from Oa4s managed to make use of all of the resources, contacts, ways-of-doing, and ways-of-being we had developed at the time of their show, and they somehow still do so.

After half a decade of making exhibitions in spacious industrial splendor, we were incentivized by a special grant from the Office for Contemporary Art Norway to participate in international art fairs. This encouraged us to work more closely with some of our past collaborators as well as with some local artists. This gallery model characterized the final couple of years of our project: we produced new works and shows with the artists in Oslo, while representing a few artists in a low-key fashion. The artists whose trust we earned and who allowed us into their studio practice and career experiences were Tora Dalseng, Ane Graff, Mikael Øye Hegnar, and Mirak Jamal (who, along with Anthea Hamilton and Nancy Lupo, featured in the exhibition *SELFLESSNESS*, which epitomized the late stage of 1857).

Opportunities

Exhibitions were the heart and soul of 1857; we did everything we could to make them as extraordinary, idiosyncratic, and experi-mental as possible. Each show, and especially the periods leading up to the shows, had a distinct feel or vibe; this is also when we hung out with artists and gathered essential collaborators and materials. As different as they were, the 26 exhibitions in Tøyen-bekken and the handful that followed were precious, rare flowers that sprang from the rich soil in which we immersed ourselves. New shows and projects were like seasonally added mulch that

was further enriched by our liberal key-copying policy and the steady addition of tools and materials (not to mention the fertilizing effects of the occasional surprise sewage backup into our main space).

An additional note on "space"

Shortly before we lost the lease on our original space, we received a three-year program grant, and we wanted to use it to establish a new model of operation, which we did not do.

We had this incredible industrial space, and people used to go on about how big it was and wonder whether the construction crane worked. Someone said this to Ad de Jong, who was in one of our early solo shows, and he replied: "Yeah, the space is good, but the guys are really good, and that's more important." Even though we call ourselves a "space" (instead of an "institution"), 1857 is much more about the people—their ideas, skills, and personalities, all of which give flavor to the space. It was hard to pack up the old lumberyard and find a new one.

The distinction between space and "institution" relates to the context of the project, the scene or community that it enters into. An institution becomes part of its context and shifts the balance; it has an extended duration. A "space" is a more dynamic intervention, consisting of proposals and counter-proposals. These two models are not clear-cut, and they can combine in various ways. 1857 employed an institutional identity to underwrite curatorial "bomb-throwing." We initially wanted to raise the bar for exhibition making in Oslo, to make our colleagues and the establishment pay more attention to the world around them and to their own contributions. Now there's a lot more going on, and the needs have changed. We would like to think we had something to do with that.

QUESTIONNAIRE

Asakusa
Koichiro Osaka

Asakusa started as a weekend venture. While holding down a full-time position as a curator at SCAI The Bathhouse in early 2015, I found a small two-floor space and renovated it with the help of local architects and artists. The 40-square-meters venue became a residence for myself during the one-year renovation period, at the end of which architect Kosaku Matsumoto joined me for a three-month on-site residency. Together we reworked the spatial design in life-size scale.

As an independent initiative, Asakusa is now run by a small team of two people—Mariko Mikami, our project manager who currently lives and works in Dusseldorf and myself as the full-time director since 2017 (I'm based in Asakusa, Tokyo). We recruit additional freelancers for each project.

We occupy a small residential property built in 1965 in Asakusa, one of Tokyo's most bustling tourist districts. Only steps away from busy streets, our building is nestled in a secluded area where 20 households live side by side and back-to-back. The gallery's neighborhood has been a major entertainment district in Tokyo since the mid-nineteenth century, then featuring freak shows, cabaret-style theaters, strip clubs that had fully nude displays, and, in more recent times, cinemas, stand-up comedy, and TV shows.

The gallery's program resonates with the history of visual culture and mass media, and brings together gender, societal, technological, and art historical references. For us, the exhibition begins as the visitor enters the neighborhood, before actually stepping into the art space. Sometimes, our exhibitions literally infiltrate the neighborhood, or we organize events at local venues—for instance, *Asakusa Entertainments* spread over several locations such as a legendary comedy theatre and even into the post office.

With our exhibition programs we aim to raise as many critical questions as possible to prompt further inquiry. We often engage collaborators (co-curators or co-organizers) in our dialogues, and in doing so we scrutinize the conditions of the here-and-now and understand our collective identities as social and political constructs. Many issues are left unquestioned and unspoken in Tokyo—this silence is the source of our curatorial activities. To address these silenced issues, we invite international

artists to conduct research in the city to then possibly produce new works.

Koichiro Osaka

Artists and artwork

We usually invite artists by email, explaining our past activities and the overall direction of the venue, as well as the aim and agenda for the specific project. All artists with whom we have worked are extremely flexible, despite our limitations (we have a small space, a small budget, and limited time and staff).

Whereas Asakusa's main curatorial framework is shaped by the cultural history of its neighborhood, we also often look into historical moments to revisit them and connect them with present issues. The exhibition *1923* (March–April 2016) for example, not only considered the impact of the Great Kanto earthquake on the Japanese avant-garde, but it also coincided with the memorial day of the Fukushima catastrophes.

The exhibition space

When the space opened in 2015, I was still working full-time at SCAI The Bathhouse, so I had only the weekends off. Since most art institutions in Tokyo are closed on Mondays, I thought it would be a good idea to open the space Saturday through Monday, especially for those working in cultural institutions. On Thursdays we sometimes open late until 10pm, for those with busy office schedules. Overall, we have little regularity when it comes to frequency of shows and opening hours.

Asakusa is situated in architecture of the 1960s, consisting of ordinary, affordable materials such as basic wood planks, thin plasterboards, and single-pane windows. There are some decorative charms to it too, such as textured, smoked glass and a wooden staircase in one corner. The space upstairs was renovated into a small white cube, to make exhibition installation more practical and easy. Many of our shows, especially in the beginning, were conceptualized remotely because I could not afford inviting the artists to install their work. If we would have preserved all original architectural features, exhibition installation would have been quite challenging. I also liked the idea of a small white cube suddenly appearing in the chaotic downtown neighborhood, like a strange balloon in the sky.

STATEMENT

QUESTIONNAIRE

Site and geography

Asakusa, the gallery's neighborhood, is a popular tourist destination famous for Tokyo's oldest temple, which used to be the city's most prosperous entertainment district until the end of WWII. We have many programs in direct response to our local surroundings. *Asakusa Entertainments*, for one, is an annual screening exhibition about the legacy of mass culture entertainment, accessed critically from a geopolitical viewpoint and also presented as a reflection of Asakusa's own multinational community. Here, we often collaborate with neighboring venues to show the videos or films.

International context

For me, contemporary art is by definition international—including its misunderstandings, contradictions, and uncountable cases of injustice across world regions and histories. It is an art of constant negotiation between different regions, both within a nation and outside of it. We emphasize interrelatedness in our exhibitions, working with a variety of international artists and often in correlation to historical political movements. Our most recent exhibition, for example, was about the Japanese Red Army (1971–2001); we showed work by Naeem Mohaiemen and Eric Baudelaire, and connected the dots among different political temporalities in Beirut, Tokyo, and Dhaka. Many of our shows track histories of proletariat internationalism.

Audience / Community

I'd like to think about audience interaction a little bit against the grain. Asking the audience to participate can be quite intrusive sometimes, and so is any other form of engagement, like a discussion. I'm more interested in thinking of exhibitions as a closed platform for silent, unspoken communication, where visitors come in and spend time without being asked anything, like a room for meditation. In our context, society has a different set of norms and virtues, and people are a little hesitant to raise their voice and engage in open discussions. So as a rule we don't interfere in the audience's personal dialogue with artworks unless we are asked to provide more information.

Voice / Communications / Press

We do create printed matter occasionally but not for every exhibition, mostly due to the lack of time, budget, and bandwidth. We produce brochures and booklets when text is a vital component of the exhibition.

Writing press releases is part of my job but it's usually done at the very last minute and is mainly intended to give an entry point to the audience. We don't have a fixed set of rules; instead, the "voice" of Asakusa emerges from our engagement with an artist's practice. So an aggregate of artists' voices passed on from one exhibition to the next comprises the "voice" of our art space.

Design / Online presence

We don't really have a solid strategy behind design or our online presence. It may sound like an excuse (maybe it is), but this is primarily because we don't have enough time or capacity.

Publishing

We haven't made any publications so far, but we have had the idea of making an *Asakusa Journal* that would exist both in print and in an online digital format. The main gist would be to invite a variety of authors to write in response to our exhibitions, to push the idea that the exhibition is a site for knowledge production.

Economy / Resources

Asakusa started as a 100 percent self-funded initiative. It started as a life project, to challenge what one can do with a salary. I was fortunate enough that my employer and colleagues let me carry on (I could have been fired for working less hours). While their support was not financial, it was absolutely crucial. Additionally, our neighbor—a warm, caregiving elderly man running a rice-dish restaurant nearby—welcomed me to the community and convinced other residents that I'm no harm to them (many thought a strange, "whatever" art space like Asakusa may potentially disturb their everyday life): his support allowed Asakusa to become part of the neighborhood's social tissue.

In 2018 we started to receive public funds from Tokyo Arts Council, Taito City Office, and the Asahi Shimbun Foundation,

we also started co-organizing projects with organizations like the Institut français du Tokyo, and e-flux, New York.

Duration / Perseverance

Yes, I think it has a lifespan. I want Asakusa to be flexible and responsive to the surrounding context, and when we can't do this anymore we should call it a day. Basically, I'm interested in promoting underrepresented areas of study. At this point, Asakusa does that for me, but when I am 70 it may make more sense for me to launch an art space exclusively for the elderly, an age group that is often disregarded by contemporary art.

Key artists

The very first exhibition featured the space itself. After the renovation, we had a launch event to present the collaboration between architect Kosaku Matsumoto and myself. Kosaku was in Japan temporarily waiting for his visa so as to return to Switzerland, where he worked. He needed a convenient place to stay in Tokyo, and I desperately needed to complete the renovation, so we agreed on a 3-month on-site residency. Initially, we used software-based sketches and architectural models, but we soon decided not to use them at all and directly work with the existing structure on the scale of 1–1; no masterplan, only physical trials and errors. And this is how we have been treating exhibition infrastructure ever since: manually and customized to each project.

Fake Daughter's Secret Room of Shame by Ming Wong shows really well how Asakusa works with artists. Wong was invited to Tokyo three times: for a research trip, for production, and for the installation and exhibition opening. This project connected with our neighborhood's history of 'light' entertainment and queered the male-centered perspective of Nikkatsu pornographic series from the 1970s and 1980s. Wong's video piece was shot and installed at the art space, making full use of the old residential house itself—matching the exact period of the Nikkatsu film it referred to.

The Imperial Ghost in the Neoliberal Machine (Figuring the CIA) was a group show with work by Minouk Lim, Yoshua Okón, and Ming Wong curated by Asakusa and held at e-flux in New York.

We brought together CIA archival sources as well as works we had commissioned by Minouk Lim and Ming Wong, and a video and sculpture installation by Yoshua Okón. This project shows how the artists' research in Japan carries beyond our own space, and how political issues are intrinsically and seamlessly connected across national borders.

Opportunities

I prefer not to make a claim that we do anything extraordinary or experimental because such a claim will be relative anyway. After all, nothing is new and someone else has done it already in the past. We are a practical, down-to-earth, problem-solving event organizer—at best, we find and connect dots scattered around the world. So we are definitely not a producer of the new, but a facilitator for the new.

castillo/corrales
Section7Books
galerie + librairie
du mercredi au samedi
de 14h à 19h

castillo/corrales
Thomas Boutoux

When I try to sum up—five years after its closing—what castillo/corrales (c/c) was, it's not so much *what* we did, but *how* we did it. castillo/corrales was first and foremost a collective, collaborative project. Everything we did came out of conversations involving several members of the collective, whether it was organizing an exhibition, giving a conference, publishing a book, or even writing a text. There was never one author or one curator attached to a given project, and our individual names would never appear. This was, at least to me, what was distinctive about c/c from the very start, and why and how we found continuous pleasure, intellectual stimulation, and professional interest in running it for almost ten years. This blend of self-effacement and generosity toward one another was never easy to maintain, especially as the space got more attention over the years, but it was the foundation of our small attempt at inventing and running an "institution" in an alternative way. On an ideological level, we aimed at articulating and enacting a model of organization/institution that involved as little hierarchy and bureaucracy as possible, and that would counter (or at least confuse) the forces at play in the (art) world that individualize everything and that consider work in the sole light of a career path driven primarily by self-promotion.

As c/c, we found freedom, inspiration, and boldness to embrace a wide range of different ways of working in order to demonstrate that there is more than one way of doing things, of making an exhibition, editing a book, writing, and so on. While this may have had little measurable effect, I'm still proud of how we resisted these trends that were becoming ubiquitous at the time, and by doing so we pointed at and criticized the idea that working should be naturally, necessarily, and ineluctably individual, without humor or friendliness, and obsessed with visibility.

Thomas Boutoux

Artists and artwork

The activities of castillo/corrales were always varied: we organized many solo and group exhibitions, but also screenings, talks, debates, performances, and concerts. There was a bookstore within the space, called Section 7 Books, which became a place for numerous informal conversations with publishers, editors, writers, and artists about their books and journals. In 2008 we launched our own imprint, Paraguay, which specialized not only in books, but also in different types of journals or series. One of our curatorial principles was to not give preeminence to artworks or to exhibitions. Every event—whether a two-month exhibition, a one-hour talk, or text—had the same importance to us: they all equally contributed to the program of the space as an ongoing conversation with our audience. We paid equal attention to both shorter events and the exhibition program. Another principle was to try to counter the homogenizing forces at work in contemporary art: we questioned the "natural" tendency for things to look "professional," to imitate (and beg for) legitimacy instead of inventing at the risk of failing. We therefore tried to make castillo/corrales an irreverent space, one that ran against those lazy expectations.

We delighted in imagining projects that were going in a completely different direction each time, that had a totally different format from the previous one. Our whole point was not to be treated as trading in information, or as being reduced to an announcement of names and dates—for us, "who (or what) are you showing next" was the most useless and irrelevant question imaginable. We wanted to keep surprising ourselves, and we didn't apply a formula or plan too far ahead. The artists and curators we worked with for the exhibitions we organized not only sympathized with this kind of playful and lighthearted approach but also pushed it further, defying the limits and habits of their own discipline. Amy Sillman, for instance, instead of showing her paintings, decided to collaborate with Lisa Robertson on a video work and to fill the room with posters, which were both unique and totally affordable. Or the so-called "castillo/corrales biennale" curated from 2007 to 2013 by the same (and self-appointed) curator, Anthony Huberman, who played with the conventions of the large group exhibition in numerous and humorous ways.

The exhibition space

We started out in a very tiny space and then moved to a larger but still small one. In both locations we used the space as our office for our respective individual activities, which meant that castillo/corrales was more or less always open, even late in the evening, except on Sundays. Our bookstore was always open, even between shows. c/c was a multipurpose and storied space, and it transformed a lot. At one point, we turned it into an unlicensed night bar called Machu Picchu by simply putting up a thick curtain in the window. We preserved the size and feel of a gallery rather than resembling an institution; overall, our infrastructure wasn't a main characteristic and we prioritized content. In this sense, castillo/corrales was more than a project space or an institution— it was a collective. We organized many projects elsewhere (in France and abroad) and for us they were an integral part of the narrative of our space.

Site and geography

Our beginnings were for the most part accidental. The founders *found* each other in a former gallery space in Belleville that had been transformed into a shared office. Belleville was at the time a bit off the art map. The rents were very low and there was not that much foot traffic because there wasn't much else around in terms of culture, shopping, or even restaurants. We started opening our office to the public with some small temporary shows. We only had between three to five visitors a day, and we aimed first and foremost at stimulating conversations. We saw castillo/corrales as a space for conversation, a space for learning, where an exhibition would be more interesting, more precise, or more intelligible after the many conversations, views, and anecdotes that had been gathered during its course. The same logic applied to the creation of the bookstore: the idea was to talk about books (and publishing practices) more so than selling them. We felt that such a space for new encounters, for intimate, informal conversations, was missing in Paris, so we kept doing it for many years. If we had started out in a more central or arty area of the city, castillo/corrales would never have existed the way it did.

Audience / Community

We didn't organize community projects in the usual sense of the word. But castillo/corrales was definitely about community building—and hopefully not a too homogenous one. We were lucky that our program appealed to intergenerational and international audiences. We never asked ourselves questions like "How do we work with the audience? What is our attendance? To whom should we reach out?" because we were not accountable to any funders. That was a blessing. Hospitality, though, was key to us; we wanted to make everyone feel welcome and curious. In this way, we were closer to a gallery than an institution. We mainly worked with formats, including exhibitions, that allowed the audience to participate. Some of our shows were left incomplete or inconclusive on purpose, giving room for the visitors to add missing information, knowledge, or anecdotes—we all contributed to a collective understanding of a question. For instance, we organized exhibitions that were more like investigations, whether on Kathryn Bigelow's life in art before becoming a Hollywood filmmaker, or on the elusive and controversial curator Christian Leigh.

Voice / Communications / Press

castillo/corrales started with a text, the "press release" for our very first show (at the time, we weren't sure there would be a second one). This is how we got a voice, and it didn't sound institutional at all. Oscar Tuazon wrote most of this announcement. The text was a set of small sentences, completely stripped of objective descriptions of what the gallery is, or what this first exhibition was about. The cadence of those sentences became the cadence of the space. They miraculously coined the voice for a group of five people (four French and one American) who had decided to work together. We always tried to write sentences where the reader didn't get stuck in commentary and expert-sounding explanation. We chose words that didn't get us involved in the business of self-praise—or when they did, it was in an exaggerated, obvious way. We made sure our language would be free of *e-flux*-isms.

Design / Online presence

As far as I remember, design strategy was never a concern and hardly a topic at castillo/corrales or Paraguay. Our websites mainly collected the announcement texts for the previous shows and events at the space. While this was informational to a degree, we did it because we liked those writings dearly and because we felt they best represented what we were doing. castillo/corrales never had a graphic identity as such: there were no posters, no advertisements, no logo, no typeface, no template. And the same goes for Paraguay: we have worked with many different graphic designers who are always free to define the layout as well as the font, size, and place of the name of Paraguay on the book. This constant flux is not a strategy and it doesn't correspond to any politics either—it's just easier that way.

Publishing

Publishing was essential for castillo/corrales and even more so for Paraguay. In our first year we created Section 7 Books (our bookstore) and Paraguay Press (our imprint). With these three activities combined, we ran castillo/corrales as a project that played an active role in the ecology of small press publishing. All of those who founded or joined the collective later on were artists, writers, curators, graphic designers who were more interested in (and convinced by) the transformative role of books, journals, and reading than in exhibitions. In hindsight, it's not surprising our exhibition space closed while the imprint and the bookstore continue to exist.

Economy / Resources

The most important aspect was that castillo/corrales was a volunteer project and a part-time activity for each of us, and was therefore a necessarily collective and conversation-based endeavor. Because of this, we also had the freedom to be non-commercial and unbeholden to public support or local politics. We never received or asked for any public (or private) support and by working this way we didn't have to. We just needed to make sure c/c's costs and overhead remained relatively low. Through the bookstore and imprint we were able to make ends meet for many years. But this economic model became increasingly difficult to

maintain, especially as rents in Paris, and even in Belleville after 2010, rose exponentially. We therefore started organizing a yearly benefit that would somehow align with our way of doing (i.e., probably not the most effective and rational gala in terms of raising money, but at least enjoyable for all). After doing it for three years, and asking friends and artists year after year to give away works, we felt trapped by our gala's success and sensed we became dependent on it. This system just felt wrong.

Duration / Perseverance

castillo/corrales never had a set lifespan, but that is not to say it didn't have one either: castillo/corrales was always in a state of uncertainty about its future. How to find the resources to keep it going, whether financial or personal (time, energy, ideas, etc.). We often ran short of these resources and at some point we had to figure out a more effective formula for the project to continue (by organizing a yearly benefit, and by planning it ahead), which, I believe, deep down signaled the end of castillo/corrales. It suddenly became a far less exciting, adventurous, and fun thing to do.

Key artists

I find it really hard to single out some artists or projects as "key" in regard to others. Every part of the program came about from a group conversation and for a good reason, and this is what is key for me. There was never a compromise behind any part of the program. We also didn't only work at our place but outside of it, as a collective, organizing exhibitions or programs in institutions. What's key to me, retrospectively, is this organic and fluid way of working. We were not just organizers, we collaborated on projects. We even started writing a feature-length film script and a TV series—both abandoned, sadly.

Opportunities

To me, castillo/corrales was the adventurous preamble to Paraguay, and to a mode of working that can remain as idio-syncratic and unbeholden as we want it to be. With castillo/corrales we learned what the value in our collaborative endeavor was and experienced firsthand what we did not want to become

(or where we did not want to get stuck). With Paraguay things are completely different from what they were at castillo/corrales: our rent is extremely low, we are not bound to setting opening hours and have fewer obligations toward the audience. It is far more simple to work on the books and projects we feel like doing, one at a time, and according to the pace of each project. We never follow a formula with our publishing: every book project is different, and the coherence of an imprint emerges more quietly and privately. It's piecemeal and very satisfying at the same time. Publishing is also less an object of attention or a subject of discussion. As a publisher you are rarely invited to discuss the logics of your imprint. As an independent exhibition space you are constantly called on to the stage. Running a space requires more self-reflexivity and definition, which may lead to becoming a little too self-focused, self-obsessed, and self-satisfied, and less attentive to what is going on in the world around you. It gets more difficult to separate what you actually do from how you want to be seen and discussed. You don't get that with publishing: all the energy goes into making a book, and then another one, and then another one. You don't have the feeling or pressure of time passing. Last year, we realized that we had missed our tenth birthday. And that, to me, is the real accomplishment.

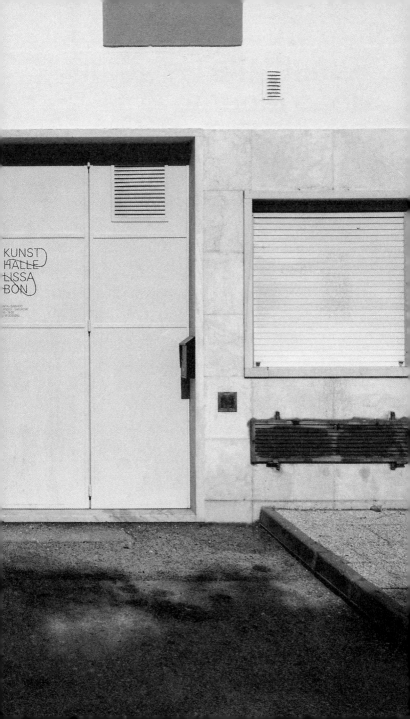

KUNST
HALLE
LISSA
BON

SFÉA-SÁBADO
SPACE SATURDAY
10 - 19.00
X R000696

Kunsthalle Lissabon
João Mourão
& Luís Silva

Kunsthalle Lissabon is a small-scale institutional project whose main goal over the years has been to think about and through institutions. We are committed to imagining what kind of institutional modes we can produce as a simultaneously local and global community. This has led us to think of generosity, solidarity, sociability, and closeness as the foundations on which we built our edifice. We see Kunsthalle Lissabon as a machine, producing relationships that are understood under the umbrella of friendship.

2019 was a moment of paramount importance as it marked the celebration of our 10th anniversary. We opened to the public on July 3, 2009, and since then we have presented more than 40 exhibitions and published 14 books. We have collaborated with numerous local and international institutions and have developed a continuous reflection on institutional knowledge and practice in the field of contemporary art. It was an incredible decade! We decided to celebrate this occasion not by organizing a party of epic proportions or by writing a manifesto on how difficult it is to manage a small contemporary art institution. Instead, we simply disappeared from the cultural landscape of the city. Stopping to reflect.

The Lisbon that was favorable to the appearance of the Kunsthalle Lissabon in 2009 had very little in common with the gentrified and touristified Lisbon of 2019. It would hardly be possible to start in 2019 as we did in 2009. We wanted to reflect on both our complicity in this process and on the critical role that we could have in imagining alternative positions for contemporary art under these circumstances. We invited four international partners—like-minded institutions—to take over the space we left vacant. We also gave them access to our production and communication infrastructure, our resources, and even our online presence. It was as if each of these four institutions opened a Lisbon pop-up version of themselves over a period of time. They had to negotiate and interact with a context that wasn't their own but for which they had to work publicly. Kunsthalle Lissabon became a radical host who gave everything it had to its guests, disappearing in the process. At the same time, we also wanted to experiment with temporary disappearance as a way of reflecting on the cultural fabric of a city like Lisbon at that moment.

We reopened in 2020 with a solo show by Laure Prouvost,

STATEMENT

a beautiful new installation specifically developed for our exhibition space. We poured our everything into that project as it was our return to curating and to engaging with an artist and her practice the only way we know how—by being together, thinking together, acting together. And then the world unravelled: we had to close down and withdraw once again from the world, this time unwillingly. The pillars upon which we built Kunsthalle Lissabon—closeness, hospitality, friendship—were now deemed dangerous as they were likely vehicles for a global virus.

As we put Kunsthalle Lissabon on pause, the political agency of togetherness became even more evident for us—it is not just an incidental outcome, it is a commitment. We came to realize that the only way to carry out Kunsthalle Lissabon is through non-socially-distanced processes. There's no way around it. As such, it is our responsibility towards our community to go on hold for now, riding out the storm and preparing for the future that lies ahead of us. Repair work will be a priority: we need to make sure the bonds we built over the years are kept alive and we need to ensure that people will regain trust and expand their comfort zones (to touch each other again, kiss each other again, stay close to one another again). With its small, human scale, Kunsthalle Lissabon is the perfect place where such togetherness can and will be regenerated.

João Mourão & Luís Silva

Artists and artwork

When we work with international artists we aim at working with people whose work has not yet been shown in Portugal, as a way of expanding what the local audience has access to. When we work with local artists we try to invite people who wouldn't have access to production resources, a communication infrastructure, etc. This basically means very young artists (and we have had a tradition of doing some artists' first solos shows) as well as people who haven't shown regularly. We extend an invitation after carefully researching the artist's practice, material requirements, resources we anticipate we will need in order to successfully develop the artist's ideas, and the degree of commitment we believe an artist can put into a project with us. We then send a personal email with the conditions we offer and the reasons why we believe an exhibition in Lisbon would be important; we propose a timeline and then we keep our fingers crossed. Each time we send these email invites, we get extremely anxious.

Our curatorial principles are founded on being together, thinking together, and working together. That's why commissioning and solo shows are so important to us. Solo shows become the public manifestation of that time spent with the artist. They are the publicly visible embodiment of a friendship relation between the institution and the artists and that is one of the core principles of our curatorial activity.

The exhibition space

We currently inhabit the third venue we have had over the past 10 years. A lot has changed in our institution and program simply because of the different spaces. Some projects would have been possible in previous spaces but not in the current one, and vice-versa. We have always thought of the physical space of the institution to be a key element in defining what we can and can't do. There's no point in trying to fit a square peg into a round hole. We are currently in a two-floor warehouse in eastern Lisbon, just outside of the city center where a few galleries are also located. On the ground floor, in addition to the entrance, we have our office space, library, and restroom. The exhibition space is downstairs, along with our storage. We occupy a total surface area of close to 200 square meters. Our visiting hours are

Thursday to Saturday, from 3 to 7pm, and also by appointment. All activities are free of charge. We do four shows per year and we try to publish at least two books annually. We are also open to the local community's needs and we sometimes host events organized by other people, even though we always try to find some connection to our program.

Site and geography

Our local context is the city of Lisbon. When we started, 10 years ago, right at the peak of the financial crisis, Lisbon was a very different place from the cool place everyone wants to visit and live in today. We wanted to open up and reach out to the outside, to what was beyond our very closed and self-centered artistic community. We wanted to work with artists whose concerns, artistic and otherwise, were aligned with our own. We wanted to expose local audiences to different ways of perceiving and being in the world, and that is what we did until last year. Meanwhile, Lisbon has changed dramatically—and not for the better—with extreme gentrification and touristification, which are promoted by the state and city and are forcing people out. We have lost ownership and use of large parts of the city. We are using our 10th anniversary program to tackle those issues.

International context

From a conceptual, ethical, and political point of view we do not make a distinction between national and international. In a way, our research tries to bypass such binary reasoning. The world is so much more complex than an either/or situation. We respond to our international context by being *in* the world and by being *of* the world. Of course, from a very practical point of view, grant-wise and such, we still need to use those categories, but we think we have instrumentalized them in a critical way that allows us to render them meaningless.

Audience / Community

We think of them as friends. We treat them the same way we treat an artist we invite, or a generous donor. Kunsthalle Lissabon is an institutional machine that produces friendship. In that sense, we are the maintenance technicians who guarantee that all those

relations are functioning properly. Sometimes you lose touch with friends, sometimes you make new friends and are thrilled about it; sometimes you miss your friends and you call them, other times you can go for months without talking to them, but you know nothing has changed in your friendship. That's how we think of our audience—as friends. This approach allows us to dismiss the pressure of audience numbers and statistics on one hand, but also creates a definition of public which is not tied to the actual presence of visitors in the physical space. Their support is not a function of them showing up or not to a specific exhibition.

Voice / Communications / Press

The voice of the institution is not defined or immutable. It changes tone, intensity, and pitch over time. Sometimes the institution is happy, sometimes it is angry. Sometimes it is tired, other times it is hyperactive. The voice, as a bodily language, is a testimony to and a reflection of all those different institutional moods. Kunsthalle Lissabon is a very playful and performative institution, ironic even. We once used the metaphor of the hoax to describe our insti-tutional voice. Kunsthalle Lissabon built itself as a performative gesture and our communication strategies reflect that. We are very mindful of printed matter for both environmental and financial reasons. All our communication is online, through mail-outs, and through our online presence—whether the website, Facebook, Instagram, or Twitter. We do have one handout with information about the show for every exhibition, which we give to the visitor, but that is pretty much it.

Design / Online presence

Kunsthalle Lissabon's visual communication and image is as important as our exhibition program or our publications. Every year (except 2019, because we disappeared as a way of celebrating our 10th anniversary) we change our logo and our image. This decision was proposed by our designer many years ago and conveys the idea of an unstable institution. It is not fixed, it is not immutable or eternal. It changes with time, with people, with resources, with installations. There's a certain tendency to naturalize institutions. They have always existed and they will forever exist, but we want to invite people to think of them as transitory, social constructs.

From a practical point of view, changing the logo and image every year is a logistical nightmare, but we have found it pays off.

Publishing
Yes. Publishing is, together with exhibition making, one of our core public activities. We publish artist books, monographs, and the ongoing "Performing the Institution(al)" series. There is no recipe or predefined approach for the way we work on a book. It depends on the artist's goals, the resources available at the time, etc. We have edited most of the books, but we have also worked with guest editors. We have worked with many designers over the years, both local and international. Some of our books had international distribution (Sternberg Press, Hatje Cantz, Mousse) and others didn't. We have collaborated and co-published with other institutions, and we've also published on our own.

Economy / Resources
Our funding structure is a combination of public and private money. Roughly 70% of our budget comes from the Portuguese Ministry of Culture and the remaining 30% comes from individual private sponsors as well as project-based funding, usually from the funding bodies of the countries the artists come from. The main constraint is that the funding we are able to secure is never enough. We are, and have always been, underfunded. Luckily, we have been able to secure a funding structure that enables us to pay wages and fees to everyone who is part of the operation. We do not exploit volunteer labor. Despite the chronic underfunding, the freedom of doing exactly what we want the way we want outweighs the financial constraints. We are not told by the Ministry of Culture or the private donors what to do or whose work to show. Actually, a pre-condition for taking money from any source is that it can't come with an "only if" condition. We do not relinquish control of the institution in exchange for resources.

Duration / Perseverance
When we started Kunsthalle Lissabon, we never thought of any specific expiration date. We did, however, think of it as a social experiment of sorts and we envisioned possible outcomes that would go from closing down due to lack of resources or personal

exhaustion to an over-the-top starchitect-designed building with a millionaire budget and the most irrelevant program both from a critical and an artistic perspective. We are slowly moving to one of those extremes, but we have no idea which one. Hopefully it will be something in the middle. Most likely, Kunsthalle Lissabon will move in one of those directions without us at the helm. Institutions should renew their staff, and we are working towards making sure we have a stable enough structure in place so we can pass the baton to others.

Key artists

This may sound a bit cliché, but one way or another, every single project, whether it is an exhibition, a book, or anything in between, has been instrumental in helping us articulate what Kunsthalle Lissabon is or tries to be. Having said that, we would like to highlight the most recent projects as they have pushed us to our institutional limits (even if for reasons that lie outside the institution itself). In the summer of 2020 we opened a solo show by Zheng Bo. It was our first social distancing show, as gatherings of more than 10 people were not allowed. No opening reception, no celebration. The artist wasn't present and there was a very limited number of people allowed in at the same time. In a very strange, yet very concrete way this show goes against all the research we have developed over the past 11 years. It counters all ideas of closeness and togetherness we have been exploring. It is incredibly eye-opening to compare this exhibition with the previous one, Laure Prouvost's, which felt like a quintessential Kunsthalle Lissabon show, especially being the first one after our year-long sabbatical. It was about working together, installing together, being together, eating, drinking, enjoying each other's company, celebrating our accomplishments together and with the audience. In hindsight, Laure's show now feels like the swan song of a very specific way of doing things (of "instituting"). Only time, and our collective actions, will tell when, or if, that modus operandi will return. We hope so.

Opportunities

That would be something to ask our audience. We honestly struggle with answering this question, as we are so embedded in the inner workings of the institution that we feel we don't have the needed distance (no pun intended) to be able to provide a meaningful answer. However, the emphasis on process over results, on relationships over objects, and on slowness over overproduction seems to be our most relevant contribution to an ongoing dialogue about what role contemporary art institutions play in this day and age.

QUESTIONNAIRE

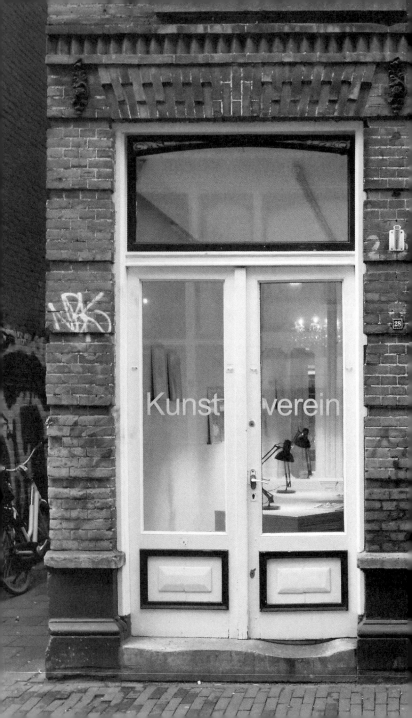

Kunstverein
Yana Foqué
& Maxine Kopsa

Enough of a Part

When a space is so small, it's like an extension of yourself. Kunstverein (KV) started with a reluctance to call itself an institution before it became one. I now see that that reluctance was naïve. I cringe when I hear my voice saying to a panel of 13 American board members of a much larger institution: "We don't want to become an institution." That's nonsense. We were one before we started. And maybe it's all about that—about having the image, a picture in your head, an aspiration, and then driving the car (more like the bus) to it. About getting there, getting out, looking around, and thinking: *Yes, this is what it's supposed to look like. This is what it's supposed to do.*

 It does feel a bit peculiar to sit here and write this about an institution at this particular time—and I said this last week to Ronja and Yana (my dear colleagues), I said: "I don't know if I'm the right person to be writing this, now that I'm actually leaving Kunstverein, on my way out, spending my last days 'in the office,' so to speak." Leaving because it's time—it's been ten years— but not only because it's time. I said: "Because what I really feel like writing about is DOUBT." There's a reason why Deepak (midlife crisis) Chopra rang true (midlife crisis?) three months ago, when for the first time I felt good about leaving KV, and leaving it in the trusted younger hands of Yana Foqué. His idea of NO JUDGMENT... Imagine that... no judgment. What is that? Extreme doubt? Like extreme sports? I don't know. But I am definitely interested in doubt, in how much space one wants to, and intends to, take up on this planet. On one point of the doubt spectrum, I wonder about the validity of showing art, full stop. There, I've said it. (Can we come up with a better way of being with remarkable people (makers), practices, and their ideas?) Somewhere in the middle of the spectrum, I wonder about the validity of wanting to have Your. Voice.Heard.(Read: MY). And, somewhere on the other end of the curve, probably the most valid end, is that the world is changing. Finally. A canon is toppled. Thank god. And it's time, and I think it's more than that—it's my responsibility to you. To take the time to think about *why*. To take one step back and a deep breath, and, well, to talk and think, and start looking at things without a functioning institution on my back, an opinion ready in the pocket,

a smart solution wrapped up like a bonbon. And to go back (back?) to the possibility of an *I don't know*.

But let's rewind. 10 years ago we started with good things. Different from what was happening—or so we were convinced, and I think we weren't far off. (And we're still not.) And it was a solid (bus) drive to try to fit these things into a Kunstverein jacket, dress them up as they deserved to be, and share them with an audience that would be both new and familiar. (Which it still is.) We were driven to put on a new model like you would a new suit and prance modestly, ambitiously, in front of a mirror to see how it looked, and, after that, to keep on trying new outfits, making sure we were surprising ourselves and everyone invited. (Which we hopefully still do.)

We made a promise not to don the trusted old blazer we had depended on more or less blindly before, to avoid jaded language, knee-jerk opening times, obvious show durations, the same old lighting. And (but?) we promised to avoid and reconsider methodologies, without becoming "alternative." Yuk, alternative. Because, simply put, it was and still is about being part of a conversation and *making* the conversation happen at the same time.

Maxine Kopsa, Summer 2019

Artists and artwork

Usually we connect with an artist whose work we've been following or researching with an invitation to do a show at Kunstverein. We usually reach out to an artist with a specific idea in mind, we start with a proposition for a show about their work, and through conversation develop a more precise direction.

You could say we're generally triggered by a current issue, or current problem—something that could be solved or addressed in a cultural, social, or political sense. From there we are led to draw parallels with people who have tackled similar issues and found inspiring solutions. Take a recent show like *Mr Peanut*, which focuses on someone who ran for mayor of Vancouver as a peanut in 1973. Mr Peanut is an inspiration, perhaps even viable "solution," to current politics.

We aim to show stories and histories that fall a bit off the grid. We're attracted by important stories that are not addressed in bigger institutions, or works by artists that are not easily seen in a gallery context. We try to share these unique practices by contesting the usual forms of presentation, hosting, and exhibition making. Expanding on "model bending," and considering as well Kunstverein's historical interest in alternative exhibition approaches, we respectfully appropriate alternative models to display content. In the past this meant kidnapping the models of a store, a library, a bar, a festival, a restaurant, etc.

The exhibition space

Our exhibition space has always played with notions of private and public. We started Kunstverein in an apartment, moved to a former saxophone shop near one of Amsterdam's biggest street markets, and are now located in an old bakery nestled between the commercial galleries, in the center of the city. The idea behind settling our institution in these types of spaces is to make it possible to reach out to an audience which might feel hesitant to step into a museum or gallery, as well as to surprise the more professional audience by bringing them a museum-level show within doorstep access, so to speak.

In part we do this by renovating the space for each show in accordance to the work on display; we alter the entire appearance of the space and occasionally its function, too. You

could say that we place extra-special care on—for lack of a better term—the mise-en-scène, whether this be a complete context-specific renovation, a precise choice of beverage, a certain light, a specific timing for a show or event. This continues to be a driving force for us.

Kunstverein's core program consists of three to four exhibitions that run for two to three months. We also hold several social events in a variety of forms and publish two to three books annually. We consider all these different program elements to be of equal value and enjoy playing with the anticipated time frame of these concepts. For instance, a project can last nine minutes (like Nora Turato's acapella cover of Rammellzee) or an event can unfold over several months (our illegal bar *Bob's Your Uncle* was in place for over a year). Kunstverein is open three days a week, by appointment. KV increasingly underlines its interest in specificity of placing, rhythm, and experiencing, in short, the prompts and ingredients that allow the story to unfold.

Site and geography
Kunstverein remains a small organization that must operate on a tight budget. As with sister institutions in Amsterdam, we feel the tremendous stress of real estate, or rather, the stress of its restrictions: there are so few spaces left at affordable rents. Kunstverein believes in remaining very much a part of the urban fabric, and maybe, due to its size, feels strongly about being in the visible public arena, close to the center, and not hard to reach. Our current location in the Hazenstraat, which is located in the center of Amsterdam, has afforded us an increase in drop-in public, and a meaningful art context within which to work.

International context
Kunstverein is a domestic franchise with sister locations in Milan and Toronto—through this network we have ears and eyes on the ground in other parts of the world. This network (and there is room for expansion!) is enhanced by other institutions outside of our own circle with which we feel connected. Many of them are represented here in the conference. An obvious connection to an international context is hard to pinpoint, though. But to be blunt, and turn that around: not having one would seem preposterous.

It's always a play between local and international, feeding the one with the other. You could say we work with niche concepts that have, we feel, a broader, topical resonance. And we try to stay true to topics and interests that are important to us.

Audience / Community

A key characteristic of Kunstverein is its attention to the collective, meaning that the audience is not only made up of the one-off visitor but also comprised of members, creating a feeling of community. Different moments in the year focus on this community, and events are geared towards its stimulation. This, of course, does not imply that a non-member visitor is any less welcome. The audience is probably a 60%–40% split between returning visitors and new ones. And everyone who walks through the door gets a tailored tour of the exhibition or project on view.

Voice / Communications / Press

Kunstverein was started in 2009 by Maxine Kopsa and Krist Gruijthuijsen out of a necessity to bring artists and practices that they were interested in and wanted to see and share. They also felt an urge to congregate with others at a time when the cultural scene in Amsterdam was in a crisis—not unlike the existential crisis the city is going through now. This aim has not changed much throughout our 10-year existence, though with different accents according to the issues at hand. An important aim was not to fall back on all too well-worn and tired traditions in terms of exhibition cycles, installation periods, and, crucially, a certain knee-jerk press release language.

When we first started we thought we would do everything by word-of-mouth only. And I still like the idea. Not as a way of shutting anyone out or of keeping it all small, but as a means of gathering a certain type of concentration: if you know you're going to hear about something once and you feel as though you are being spoken to directly, you listen differently. It's like reading something with the intention of telling someone about it right after. Practically speaking, we now communicate with our audience mainly via our newsletters—this is where our voice can get personal, or at least we try to do so. And they tend to be long (too long, according to a board member who is a communications

expert). We make joyful handouts, but we try to limit the amount of predigested text in the space. We want the visitor to view the works without the clutter of captions, and to enter into a dialogue with us as we narrate the story of the project live. So a lot comes down to oral transference.

Design / Online presence

Maxine has been teaching at the Werkplaats Typografie for over 10 years now, and when she and Krist started Kunstverein, she approached her students with the creative brief. Jaan Evart, Stephen Serrato, and Marc Hollenstein decided to collaborate on the Kunstverein graphic identity. And Marc is thankfully still at it! Kunstverein has no explicit strategy. But as mentioned, we always search for ways to avoid generic forms of cultural institution communication. From the start, we had an aversion to images on the website, or we hadn't found a good way of dealing with them. And we're still working with the same site... though we have plans and a solution ready now, they just need to be implemented. But where's the time? And to be honest, the website is so old and so not contemporary that it's starting to gain in charm.

No strategies! Or seemingly so.

Publishing

Kunstverein has a publishing house which functions as a shared imprint by all three sister locations. These books are not considered as a footnote to the program but as a separate, equivalent platform. The publication is considered an exhibition space in itself; one that is able to convey ideas about art in a different way. This way of thinking was in part stimulated by our former board member Seth Siegelaub, who was quite radical in terms of pushing the envelope of art showing. He was a very important voice for Kunstverein from the get-go, and we still happily hear it ringing in our minds/ears. Because everything is published in English and distributed by Idea Books, Kunstverein is able to contribute to international discourse from its small-scale but agile position.

We edit most of the publications ourselves in close collaboration with the writer/artist. This is not necessarily a perfect situation as we tend to run out of time, but we like to be

closely involved in the material. Most books in our imprint are designed by our respective in-house designers (in our case, Marc Hollenstein) and with members of our team having a background in design, we have a lot of know-how sitting right at the work table. Depending on a specific project, we sometimes work with other graphic talents; for our writers' series, for example, the authors whose essays we publish choose the designer with whom they want to work.

Economy / Resources

Kunstverein receives its funding through a complex synergy of systems: like many institutions in the city, we receive support from both private and public funds for our program or specific projects. Our main fantastic sponsor, from whom we receive a four-year grant, is the AFK (Amsterdamse Fonds Voor De Kunst); before them a similar grant came from the city. Sometimes we are sponsored in kind by private companies such as hotels and paint suppliers. We sporadically come up with self-sustaining economic structures like the bar or restaurant nights, but those have never proven to be sustainable (or lucrative) for a longer period of time. Most importantly, the success of Kunstverein comes from the support from our members. The annual donations by supportive individuals keep our program independent and, we feel, deserving of a place in the city. The budget is tight. And we have to count every penny to make things work. But having a four-year stretch to work within, securely and safely, is an incredible opportunity.

Duration / Perseverance

We started off saying we'd try it for a year. And then two. And now it's been 10. We hope to stay sharp and enthusiastic, and continue to feel the urgency to show and share. So perhaps "change" is a better word than "ending."

Key artists

Without a doubt, *Bob's Your Uncle* (BYU) is one of the key projects we set up. It's exemplary for the way we work, because it radically transformed the function and look of our platform. It was a stage set designed by the California-based artist Robert Wilhite (who was also the right hand to the late structuralist artist and

playwright Guy de Cointet) that also doubled as a functioning bar, open weekly. We started it in 2014, but got exhausted in 2016 by the fast, weekly turnover of the program. For a stretch, though, it was a place in Amsterdam were you could find your fellow-Thursday-night-no-other-plans peers, and the art that was the excuse to leave the house in the first place moved over and under your feet and into your hands, becoming the cocktail you consumed, the walls, tables, and chairs surrounding you—a chance to meet, talk, and watch others perform, closely. It focused on performance art (understood in the broadest sense of the word), and brought a different host and served a special drink weekly. Some of the most notable nights included BYU#20 where Adam Pendleton read Hannah Weiner from afar and BTY #41 where Ian F. Svenonius performed ESCAPE-ISM Serving The Last Word.

Opportunities

Our humor, playfulness with scale, time, and medium are defiantly peculiar and make us, us. Then there is also our reluctance to repeat ourselves. "When you feel that you have become a slave of something you initiated yourself: STOP," Seth told us once. We live by that expression, and maybe someday we'll run out of ideas and do just that. It's all a learning curve. Kunstverein, as an institution, still sometimes feels like dress-up hour. It feels more like a cloak than the archetypical blazer—a cloak one under which your hands can be idle but that allows us to take a seat at the table, to shake hands, lean in, and then divert the topic of conversation. This "institution" started out, and still is, based on friendship and trust. Not only from within the team running Kunstverein, but also towards its audience. And with that friend-ship comes the responsibility of some serious peer-to-peer ass-kicking, by facing and pointing out uncomfortable facts, taking a long, hard look at our own blind spots and not necessarily knowing how to solve them, but wanting to look for solutions. This push and pull is what makes Kunstverein live up to its mission statement: to reflect upon the manner in which cultural practices are traditionally administered—and then, to find new cures.

QUESTIONNAIRE

**Louise Dany
Ina Hagen
& Daisuke Kosugi**

The Louise Dany community grew from our home, a ground-level flat with direct street access; our small living room functioned as the main exhibition space, and our kitchen as a bar. From here, we wanted to start and support conversations we felt were under-represented in the Oslo art scene, and to address the question: "What is an art organization that we can live in and with?"[1] Our work was thoroughly rooted in our own experiences as artists.

We modeled our ideal public moment on conversations between artists about each others' practices. With the aim of supporting and highlighting experimentation, we provided environments of dedication and care, and fostered collaborative processes and dialogue about queer and postcolonial discourses in the arts and elsewhere.

Our initiative was named after Louise Dany, the house-keeper-turned-life-companion of Irish designer and architect of the Modern Movement, Eileen Grey. The floor plan of one of Grey's most iconic projects, E. 1027, reveals that—despite Grey's ambition to "build for the human being"[2] and create spaces with exceptionally fluid functions—Dany's quarters remained humble to the point of absurdity. Even if Grey's rendering of E. 1027 was a queering of space,[3] to us, she had reproduced existing assumptions of class and power hierarchies. Either this was done knowingly to provide a front and refuge for another kind of relationship, or it revealed her structural blind spots. By invoking the character of Louise Dany and her illusive relationship to Grey, we opened our home to collaborators while acknowledging and aiming to address the blind spots that we ourselves and our loved ones carry and reproduce.

Through collaborative programming we aimed to broaden conversations about colonialism, class, gender, and postcolonial thinking, and we invited artists and educators Aeron Bergman and Alejandra Salinas to curate the first public program at Louise Dany, dissecting the notion of taste as a universal given.[4] Alongside this project we organized critical salons for support and development of work in progress, and public or semi-public events in collaboration with artist-run or artist-led initiatives, institutions, or collectives.

There was no other place for Louise Dany to exist but in a home. For us, art is a way of being in the world with others. While

deeply aware of the instability, risk, and precarity that artists and cultural workers experience, our aim was to highlight the curiosity and excitement that we believe is crucial to thrive against these odds. Louise Dany was committed to solidarity across differences (political, financial, social), and to the love of learning through conversation and bringing people together. That, for us, is the social form love takes, and it became Louise Dany's aim and method.

Ina Hagen & Daisuke Kosugi

1 We are referencing the words of James McAnally, co-initiator of The Luminary of St. Louis, who we were privileged to host in 2017. https://temporaryartreview.com/the-work-of-the-institution-in-an-age-of-professionalization/

2 From the 1929 issue of *L'Architecture Vivante*

3 For an in-depth reading on this, see Katarina Bonnevier *Behind Straight Curtains: Towards a Queer Feminist Theory of Architecture* (Stockholm: Axl Books, 2007).

4 With Pierre Bourdieu's *Distinction: A Social Critique of the Judgement of Taste* as shared reference, Bergman and Salinas proposed *INCA Abroad: WEIRD Universal Art—Dialogues on Power and Representation.* INCA stands for Institute for New Connotative Action; WEIRD was an invented acronym for White, Educated, Rich, Democrat-leaning.

Artists and artwork

The selection primarily followed our interests and affinity as artists; the synergy of influences that would come out of our collaborations shaped our rationale. Our program came about through different processes, initiating contact via email or discussing ideas in person or via video. Many invitations built on previous dialogues, which we would pick up again with an artist, group, or curator while suggesting a new collaboration or dialogue. A core idea for us was to work in collaboration with other initiatives, artist-run or otherwise, mutually defining the terms, ideas, and approaches, and preferably doing so through meeting in person.

We would often invite collaborators to test unfamiliar formats, present unresolved projects, or step out of their regular modus operandi. The exhibition form was not a requirement, rather the public-facing aspects of our collaboration could be a site for experimentation in form, content, or publics. As such, we facilitated the production of work and had a collegial involvement in that production.

The concepts of home and host provided a framework for our working methodology. During production days we often lived, cooked, and worked with our collaborators at Louise Dany, sometimes for weeks at a time. Our aim was to facilitate and give visibility to the kind of conversations, works, and attitudes to art that we felt were important. Exploring thoughts, experiences, and world views can be transformative—whether through artworks as they are presented, in their process of becoming, or in their review and study. Review and reflection were therefore key to our process.

The exhibition space

Louise Dany was our home and blurred the borders between life and art, public and private. This quality fundamentally shifted the conversation, atmosphere, and attention. We emphasized the relations that naturally occur in a domestic sphere, simply because they gave for a fruitful state of mind for sharing and reflecting on art and the world.

There were certain practical limitations (stipulated in our rental contract) to how much we could modify our physical space, but we tried to accommodate whatever was wanted or needed to the best of our ability through negotiation and a creative approach

(whether it was building a wall, putting up a light rig, or trans-forming our space into a garden).

Our opening hours would always vary according to the project, and we accommodated our schedule to whatever times the artists would want. We also avoided a fixed turnover of exhibitions and public events, and instead adjusted the frequency and scale relative to whatever else would be going on in our lives (related to time, resources, budget, etc.), making a conscious effort to allow ourselves breaks when necessary.

The general working conditions of art practitioners require that we capitalize on our personal lives and private time in a major way, but this is often not visible in exhibition settings. With the particularities of our physical space and our approach to the logistics of Louise Dany, we explicitly discussed this dimension of our profession—we did this in our space and with our collabo-rators, as well as in interviews and seminars that we would attend.

Site and geography

We were situated in an exclusive residential and retail district on the West side of Oslo, which is mainly white and upper-middle class. We didn't aim to connect with our immediate neighborhood. Our community engagement lay elsewhere even though we did want to give visibility to a diverse array of people in and around the space itself. At the time in Oslo, interesting and distinctive artist-run galleries seemed to focus on expansions of, or surrender to, the white cube in various ways. There was a need to diversify the way art was approached and encountered in the city. Our deliberate choice of a domestic space was prompted by this specific context.

International context

We participated in symposiums and gatherings in various places and learned from alternative spaces and their organizers around the world. Through our individual artist practices, we also got further exposure to international peers. We consistently focused on what we could learn from their experiences, forms, functions, positions, and expressions.

We kept a healthy distance from aesthetic styles that gain traction at any given moment, because our focus was not to

showcase what is most 'new' or 'relevant' but to reflect on *why* something exists and is encountered. We often discussed questions of hosting, cohabitation, caring, and empathy, and we embedded these values in the structures of our projects, especially early on. We also focused on the refraction of these values through more art-specific notions, such as representation within image-making, visual literacy, languages, and the construction of cultural, artistic, or economic narratives.

Audience / Community

Our primary contact was with the art community in Oslo, which also included an international network, temporary or past inhabitants of the city, and those who passed through. Still, there were always some new faces in attendance. Because of the nature of our space, we got to know collaborators and made an effort to connect them to each other. They became our community. When we hosted semi-public events, such as group critiques, we invited a small number of specific people to keep privacy and generosity around works in progress.

It was important to question the assumption that an outside force is a dangerous unknown (and, inversely, that an insider is a benevolent actor because of their intimate knowledge)—Sondra Perry's *Resident Evil Seminar* in 2016 definitely influenced us in this regard. We were interested in the figure of the alien as the unknown and wanted to detangle it from connotations of danger, unpredictability (in a negative sense), or being out of touch or unable to adhere to local codes. The invited artists basically started out as aliens relative to our initiative and audience. Yet, in giving them our keys and explaining how Louise Dany could be used as their own resource, we included them as complicit agents. For the landlord and perhaps to our neighbours, Louise Dany always remained alien. Our intention was to distribute this alien agency to our collaborators—by inviting them into both the institutional frame and our own living space—and to our visitors as soon as they set foot through the door. Because of the intimacy of the space and the nature of the projects we presented, we didn't really have onlookers; instead, all visitors became involved somehow on an individual and interpersonal level. We did expect an unusually high level of engage-

ment from the artists we worked with and the audience/
participants/community we reached.

Voice / Communications / Press

We prioritized exchange over distribution. After hosting several
semi-public group critiques we learned that 12 was the ideal
number of participants for an equal, engaged, and focused
conversation. From then on we spoke as if for an audience of 12.
When writing, we drifted in and out of a somewhat personal tone,
and tried to keep most writing fairly short. When referring to
Louise Dany it was always in the third person, with the gender
neutral pronoun "they."

We primarily focused on exhibition texts that we
developed with our collaborators. These texts would sometimes
be printed and made available in the space, while other times they
would exist on our website or in our newsletter. Because Louise
Dany had conversation and discursive programming at its core,
text was often a good way to document and disseminate ideas that
we and our collaborators wanted to make available. This, together
with interviews and features, seminars/conferences, and so on,
made up the largest part of our communications rationale. With
the newsletter we interfaced with a larger, distributed audience.
Individuals from the press were subscribed to our mailing lists,
but beyond that we kept the work on press releases minimal, and
didn't aim to distribute documentation images or press texts.

Design / Online presence

Our website functioned as an index with links to our collaborators'
projects and websites. We didn't showcase documentation
images because we wanted to withdraw from the image-based
attention economy that impacts how work and exhibitions are
seen and valued, and because images conveyed little of the actual
content of our events. Online we did feature other ephemera,
like workshop descriptions, references and reading lists, texts and
interviews. For process reports and announcements, we mainly
used Instagram.

Most of the time, Ina would make posters and lay out the
website and newsletters, and get feedback from Daisuke and other
collaborators—we saw it as a fun, low-key way for us to think

about our projects visually. We played with the visual identities of our collaborators, and we also tested our own aesthetic preferences and interests in an ever-evolving graphic presence. On one occasion we worked with the collaborative design firm and publishing house Hardworking Goodlooking, which was cofounded by an artist and designer we had invited to our program. Depending on the project, Louise Dany would take on different "faces"; for *INCA Abroad: WEIRD Universal Art—Dialogues on Power and Representation*, we molded LD's newsletter and exhibition text after The Institute for New Connotative Action's (INCA) design and typography. During the three-month project *Nine Herbs Charm*, LD appeared on Airbnb as a host, while also appearing on Instagram and in our newsletter as a pseudo tarot reader, sharing weekly elusive messages.

Publishing

While artists publications and printed matter did figure heavily in our program, we did not publish in print form. Publishing was limited to digital formats, or existed as part of an artist's production. It is our hope that we'll be able to revisit projects in the future through co-authored, co-produced artists' publications.

Economy / Resources

We chose to make use of the home/art-space model to alleviate the dependency on sources of income, and to avoid any outside pressure to keep up productivity or relevancy towards funding bodies.

Louise Dany combined a range of sources: institutional collaborations, grants, and alternative funding structures like Airbnb. In the beginning we funneled our own fees from a few key institutional collaborations into Louise Dany. This allowed us to fund the first few projects. Our budgeting always started with fees for our collaborators, as well as funds to cover their travel, accommodation, and food. The group critiques would be the cost of a dinner, which we paid for ourselves or in collaboration with others. When we worked with INCA we obtained some project funding from the Arts Council Norway. In 2019, they granted us Arrangørstøtte, a public grant that covers the administrative labor of artist-initiated projects like ours. This grant exists thanks to the

tireless work of UKS, the union for young artists across Norway. It enabled us to redistribute funds to our peers locally though a group exhibition in spring 2020, as well as cover our own labor that went into it.

What was obviously not accounted for in our economic model was the cost of our own labor, which is not something we recommend or endorse. But because Louise Dany was our home, we only had one rent to cover. In order to balance this ethical dilemma, we had to be very serious about taking breaks or following other professional obligations. For us, the initiative had to be one we could live with, not one that had to stay alive or productive at all cost—and this is our ideological stand.

Duration / Perseverance

We always imagined that Louise Dany would grow and develop with us and with Oslo. Our priority was to allow enough space for our artistic practices, personal lives, and the home alongside it. When we left our Oslo location in 2020, Louise Dany eventually came to a close. Despite the closure, the mode of conversations and collaboration that Louise Dany set forth will continue in each of our artistic practices, as well as in our work with peers through research groups and our affiliation with existing educational programs. We embraced instability and irregularity for as long as we kept it running, but after four years it was time to bring it to a conclusion.

Key artists

Artist Sondra Perry, who stayed with us in August 2016, beautifully explored the concept of the alien as an image of Blackness, while referencing Sun Ra and Arthur Jafa. Our time with Sondra convinced us of the in-house co-living residency form that made up an important strand of our programming. *The Resident Evil Seminar* led by her included an artist presentation, reading groups, and a screening program.

Clara Balaguer of The Office of Culture and Design (which she runs with Kristian Henson) organized *HOHOL*[5] *Sleepover* in November 2016; the project featured a digital library, a pirate copy session, a screening of *Lupang (The Land That...)*,[6] and a conversation staged as a dinner. We set up a digital library and chat

room called the HOHOL Library as a local area network (it was accessible by any device when physically present in the space), and presented *Sukit sa Malamig: The Problem(solving) Dinner*, inspired by the *Tribal Kitchen: The Aytas*,[7] a project journal and cookbook of 30,000-year-old recipes. The event was based on an open call for dinner guests from the local art scene, who were invited to share an unresolved conflict involving one or several colleagues. The dinners or lunches that we would prepare and host were central to our program and were fully integrated into this project.

 The *HOHOL library* became an important resource for us and later fed into the project *Whose Organs Were Those of a Leopard?* by Slow Reading Club (Bryana Fritz & Henry Andersen). It also served as a dialogue platform during *Nine Herbs Charm.* This project was a 10-week residency and co-living project centered on nine plants with different medicinal properties that artist Hannah Mjølsnes of the collective Nine Herbs Charm together with artist Miriam Hansen cultivated inside Louise Dany's storefront. The project could also be experienced by booking a stay via Airbnb, and included guest appearances by artists Alexandra Dragne, Marthe A. Andersen, and Saewon Oh. This accumulative and participatory approach to collaboration in the arts was important to Louise Dany throughout.

Opportunities

What stands out to us today is our emphasis on *being present*, thinking, talking, eating, and staying together. Being people. Being citizens. Being human. Our domestic approach to programming set us apart. As long as we felt close to this core value, everything else could change around it. We didn't aim to reach a conclusion to this process of institutional learning and reflection, and we were privileged to not have a fixed set of external criteria to respond to for funding.

QUESTIONNAIRE

5 HOHOL is a Filipino acronym for "hang out, hang out lang," which is slang for a platonic date.

6 *Lupang (The Land That...)*, 2015, Clara Balaguer and Stefan Kruse Jørgensen.

7 *Tribal Kitchen: The Aytas* is published by OCD publishing house Hardworking Goodlooking, Manila/Brooklyn, 2014.

Lulu
Chris Sharp

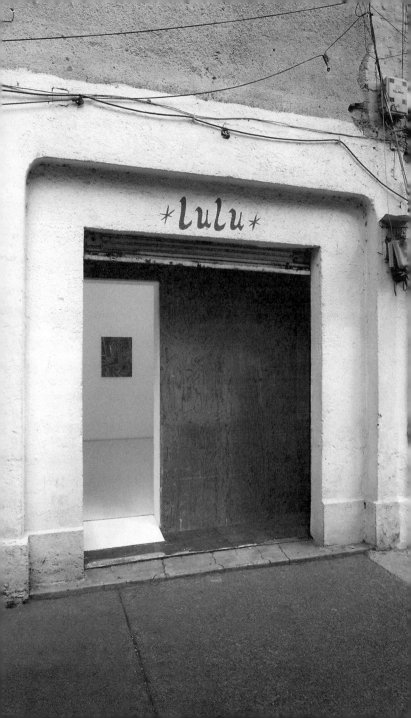

Lulu was founded by myself, Chris Sharp, and Martin Soto Climent in April 2013 in the Roma Sur neighborhood of Mexico City. At the time, the hope was to simply contribute to our local community in a sustained and consistent way through the formation of a space and an exhibition program. Since then, our mission has evolved to present artists who have had little or no exposure in Mexico City, and perhaps more importantly, who (contra the locally dominant academicism of sociopolitically engaged conceptualism) think plastically. In other words, practices in which form is not merely secondary to content, but absolutely inseparable from it. It is not a question of an artist formalizing a given idea, research results, or political position or ideology, but rather that the artist's politics, identity, and specific interests are consciously indivisible from the materials they use and the form these take. It's a question of a fully integrated position; not of transmitting an idea or one-to-one communication (i.e., propaganda). This inevitably leads to prioritizing classical medium-specific practices because these are the kinds of practices that tend to embrace form as a primary, as opposed to a secondary mode of thinking. As such, we are interested in artists who are committed to the complex and specific histories of the medium in which they choose to work.

Lulu parts from traditional institutional practices by virtue of its deliberately intimate scale, strong curatorial voice, and unconventional economic model, which foregoes observing the mythical separation of church and state, i.e., the hard distinction between the commercial and the institutional within the art world. Fully self-sufficient, Lulu sells work and participates in art fairs in order to remain totally autonomous from the exigencies of public and foundational funding, and to pursue an agenda that feels more committed to supporting the artwork and artists' formulations and formats than any given ideological trends.

Chris Sharp

LULU

Artists and artwork

Lulu's invitations to artists are based on the formal boundary-pushing of their practice and its capacity to impart a productive friction locally and within Lulu's program in general. The idea is to offer the local community, as well as artists, exposure to the kind of work they won't otherwise see in Mexico City.

We also prefer showing artists who signify individually rather than artists who depend on their immediate social context and its shibboleths. This focus is a result of being more interested in artistic conversations that move beyond small and (typically) more closed colloquies. In other words, it's not about a scene per se, or a representative of a given scene, but the artist and individual.

The exhibition space

Lulu first consisted of a single white cube which measured nine square meters, constructed and inserted into a private living room, which is still accessed through a private apartment in Roma Sur. Two and a half years later, this was joined by a second, street-side space, which was a slightly larger (twelve square meters) replica of the original space. In contrast to the relative informality of independent exhibition spaces in Mexico City, Lulu had every intention of imitating the hyper-formality of the white cube. It's a question of economy and hyperbole: how can you basically go beyond the call of duty with as little as possible?

Lulu typically hosts six shows a year, is open on Friday and Saturday from 2 to 6pm, and otherwise by appointment. We regularly receive requests for appointments throughout the week by both local and international visitors, and a good Saturday will see about 20 visitors.

Site and geography

Every exhibition aims to respond to and impact the local context in a positive and productive way. Our exhibitions are made first and foremost to be visited and seen in person. However, it should be stated that our local audience is not necessarily our primary audience. We are involved in a decidedly international discussion.

STATEMENT

QUESTIONNAIRE

International context

One of the reasons Lulu is and intends to remain independent from the pressures and expectations of a conventional institution—such as having a board, applying for grants, and all the issues regarding audience attendance this often entails—is the wish to stay lightweight in the best sense of the word, i.e., able to nimbly react to the attraction of a new artistic position. This also means less pressure to conform to international, ideological trends (such as identity politics). Our duty is always, if a little anachronistically, to art itself. This does not mean that we are not mindful of questions of nationality and gender, we are—we have to be in Mexico, which has a tendency to be both highly nationalistic and, above all, male-dominated—but, again, our primary commitment is, as unfashionable as it might seem, to art itself.

Audience / Community

We try to be as open and welcoming as possible. While we could probably increase our local connection if we showed local artists, we have made a deliberate commitment to showing art that is not yet made or seen in the city. We have a healthy relationship with our target audience (which is international)—this includes visitors as well as online followers from abroad. That said, we always give guided walk-throughs in English or Spanish to anyone who visits. This direct mediation is notoriously integral to our identity.

Voice / Communications / Press

I, Chris Sharp, write all the press releases and handle all the communication, which is in both Spanish and English. The intention with our communication is to be clear and informative, helping new viewers gain access to the work as effectively as possible. Given everyone's increasingly limited attention span, I try to keep things short and sweet and to the point. We generally have a press release and a map, accompanied by catalogs when the artist has some available.

Design / Online presence

Any kind of strategy we developed was by accident. Martin designed a very attractive logo, which he drew over the door of the small space, and which we painted over the façade of the large

space when it opened. Although the logo was incidental to our project, it has since become integral to our identity and communication, now further disseminated with tote bags which were initially produced to celebrate our fifth anniversary. It has taken on a strategic importance that helps contribute to our mnemonic traction, which, when you consider the myriad spaces vying for attention, is not negligible in today's oversaturated art world.

In terms of online presence, we realized early on that due to not coming from a western center (New York, Berlin, etc.) and therefore enjoying limited foot traffic, it was crucial that our documentation be of the best quality (we always use the same photographer, Ramiro Chaves, who is also an active Mexico City artist). It became clear that each exhibition was actually two exhibitions: the most important in the physical space, and the other online. As such, we do our best to make sure that each exhibition circulates online as much as possible.

Publishing

Not as much as we would like. We have, however, produced a few. With one exception, we always work with Mousse publishing. They design and distribute the books. We always do a catalog for each Lulennial (Lulu's biennial/triennial exhibition), which I coedit with whoever my co-curator happens to be.

Economy / Resources

Initially, we tried to apply for grants and support, none of which we received. Almost by a fluke, we sold a work from our first show, which helped us realize that we could support the project through our own commercial efforts. Therefore, we do sell work out of Lulu and do participate in art fairs. Generally, we do a solo with an artist and then a solo booth in an art fair. If they don't already have representation, this often leads to it, which we try to facilitate, as well as helping them develop an economy, i.e., an active and interested market in their work, with which to continue.

It is essentially a commercial model that more or less works for us, because it allows us to operate with relative autonomy and do what we want to do. But it is not without problems, not to mention prejudices. Many, on both sides of the

divide, look askance at curators who dabble in the dark side, e.g., selling. Doing so is generally met with disapprobation. I both understand and even sympathize with this prejudice, and find it absurd. Even though the separation of church and state is a complete and total myth, it is a useful one, lest the art world completely descend into unbridled inequity and anarchy. In the end, it is a question of priorities and integrity. Am I making decisions based on personal financial gain or am I doing so with the intention of fighting the good fight? For me, it is always the latter.

Duration / Perseverance

I would like to see Lulu hit a decade, at least.

Key artists

One of our more ambitious initiatives is the Lulennial, a sort of micro-biennial/triennial, which takes place every two to three years. Co-curated by myself and one outside invited curator, the Lulennial has a theme, features an ambitious list of artists, and is accompanied by a fully illustrated catalog which is published by Mousse publishing. The Lulennial embodies the spirit of Lulu by virtue of the essentially contradictory nature of the exhibition format: despite its outsized ambition it is characterized by a radical economy of means, scale, and focus. It is also a bit absurd to hold a biennial in such a small space.

Otherwise, I feel like every exhibition has been key, but some embody Lulu's mission more clearly than others. Manfred Pernice's solo show in 2016 is a case in point. Everything about this show, from Manfred's highly plastic thinking to his interest in provisional, vernacular architecture, and the way this interacted with the provisional nature of Mexico City was crucial. Exhibitions by painters such as Aliza Nisenbaum, Paul P., Federico Herrero, or Frieda Toranzo Jaeger speak to the complex political nature of painting, while exhibitions by sculptors such as Miho Dohi, Matt Paweski, B. Wurtz, or Kate Newby speak to the importance of form and materials at Lulu.

Opportunities

Our successes could be defined by raising awareness around issues of scale and economy—that "big" does not necessarily equal "better" and that it is possible to make an impact with very little. Additionally, unlike an institution, and perhaps more like a gallery, I think we developed a reputation for introducing new emerging and overlooked positions to the discussion of contemporary art on a pretty consistent basis.

After almost eight years in existence it is clear to me that our weaknesses have to do with local audience engagement. Lulu was initially created with the local as its target audience, and as time went by, its target audience eventually became much more international. It takes a special skill and capacity for diplomacy to keep both of these kinds of audiences engaged. This perhaps could have been addressed through a more extensive events program, but the radically reduced scale of the space made it difficult to host events like we wanted to.

New Theater
Calla Henkel
& Max Pitegoff

New Theater was born from a late night conversation at a bar we were running called Times. We kept a tab book, writing down who was coming and going, what they were saying or doing or buying, the night's gossip becoming entangled with its economics. We gradually realized it was turning into something like a script. At that point, we had been working with performance for a few years already, and we were interested in countering the sterility of performance in the white cube. So we thought: why not extract the intensity of the bar and put it onstage?

We had no experience in theater, but most of our work was collaborative, often with large groups of people. We were interested in dramatizing the conditions of working collectively, and our first plays unpacked the ethos of an artist-run space. We mimicked it, confabulated it, and riffed on our own idealistic desire of collectivity. In the beginning, we rethought the group show as a play in which artists performed onstage alongside their own and others' works. We began by writing and directing our own plays, and inviting friends, who also had no theater experience, to do the same. We acted, did the lighting, pulled the curtains.

Alternative spaces are formed from a patchwork of rules developed through different personalities, preferences, allergies, and past lessons hard-learned. At New Theater, we had a rule that in order to pitch a play, you had to first participate in another play; this way, a shared language developed between collaborators. From 2013 until we closed in 2015, we produced about two dozen plays and performances with around 80 participants, all taking place at our original location in a storefront in Kreuzberg.

As a space, New Theater borrowed from the conventional structure of theater, using its rules almost metaphorically to develop a collective system for working, where each role, both on the stage and off, created room for the individual while also contributing to a whole. Egos were put aside, and everyone's work functioned together for the hour or so it was onstage.

We relied on the gasoline of the amateur, and hardly ever worked with professional actors. We learned theater as we trolled it. Scripts were edited through rehearsal, where often the plays themselves developed and changed, sometimes addressing topics immediately at hand—the realities of living in Berlin, rents, Nazis, gay bars (as in Julien Ceccaldi's *It's Just Us*), collective planning,

collective failure, herpes outbreaks, and the limits of art (as in our own plays *Farming in Europe* or *Apartment*)—and sometimes creating completely irrational alternative Berlins onstage (as in Georgia Gardner Gray's *DD Mood* or Leila Hekmat's *Mercury in Retrograde*). The space was smallish, so the audience was also smallish, creating an intimate feedback loop where almost everyone in the audience knew someone onstage or backstage, or had been there themselves at one point.

We worked quickly, producing one new play each month, building not only on the previous plays, but on the previous night's conversations, and the concerns of the audience and the performers. But above all else, New Theater was a social space. The seashell-cladded bar in the back functioned as the space's central nervous system, where the audience merged with performers just minutes after their bows, performances still ringing, open to dissection, marking for many the real beginning of the night.

Calla Henkel & Max Pitegoff

Artists and artwork

There were no clearly defined curatorial principles at New Theater —rather, we relied on an economy of pragmatism, friendship, and proximity. Our role was always somewhere between producer and collaborator. Mostly we worked as artists, attempting things we had never done before, and inviting other artists to do the same. It was an experiment that grew outward: we invited friends and artists we admired who were living in or visiting Berlin; they invited others, who then in turn invited others. For some it was the beginning of a new way of working that has continued well after the space closed. We were surprised by how many people, after a drink or two, admitted they wanted to act.

Our first play, *Oper der Stadt Köln* was a stretch, a blind leap into an unknown form. We had a rough idea and asked those who were closest to us to help. Skye Chamberlain, a painter and furniture designer and one of our oldest friends, painted the massive backdrop of the Kölnischer Dom, and when it proved to be too big a job he brought in another friend, Patrick Armstrong, to help. Matthew Lutz-Kinoy (then Max's partner) and Hannah Weinberger, both artists, had just formed a band called LKW. They played the role of the street band. Calla got in touch with Catrina Poor, an old friend from high school studying opera in Vienna, to sing. The plays were personal and grew from who and what was around us in Berlin at the time. By the second play we directed, more people around us (not just our partners and old high school friends) had started to understand the form, and some were drawn into the process. For *Farming in Europe*, Yngve Holen decided to participate by putting his entire kitchen onstage, transforming the staging of the play, which took place around his refrigerator, kettle, and toaster oven. Over time, the plays tied disparate practices and works surrounding us into a narrative.

The exhibition space

The storefront space was previously a grocery store with a tiled floor and a meat locker, which we redesigned as a proper (if small-scale) theater, with a bar in the back. We built out the theater with a wooden stage in six detachable sections, dozens of barely comfortable wooden benches for the audience, a blue velvet stage curtain, makeshift lighting rigs, and a backstage area

full of props. Outside, we hung a new framed poster for each production, which we later hung in the bar. The theater sat around 50 comfortably and 80 packed in with standing room. We staged a new production almost every month, some one-night-only, others with a run of up to six consecutive performances. The plays began around 9pm and the bar stayed open afterwards until much later.

Site and geography

New Theater operated in English for a mostly art-adjacent audience that included many non-German speakers. The pieces were always made with this audience in mind, aware of how they would be read in Berlin, well aware of the types of inclusions and exclusions that language presents onstage, especially in a city with a looming tradition of German-language theater. Our small storefront space functioned far away from the revered, Brechtian —very well-funded—world of proper German Stadttheater.

International context

New Theater enjoyed a certain provincialism, staging traditionally narrative plays for a local (but also always international) Berlin audience. We made a rule never to perform as New Theater outside of our space at Urbanstraße in Berlin—we considered New Theater a *space*, not a *company*. We also made a decision in the beginning that we would not release video or photo documentation of the plays, emphasizing presence over mediated form. This contributed to the plays living more in memory, in gossip, and in the urgency for presence.

Audience / Community

New Theater was structured as a community theater where roles—actor, director, ticket collector, audience member, bartender, late-night bargoer—varied from person to person, and from night to night. The heightened attention paid to performance did not begin and end with the curtain. There was a sense of intimacy between audience and stage where any one spectator's presence was just as intrinsic to an evening as any one actor's performance. From the outside, this sloppy familiarity could seem off-putting, but the bar acted as an equalizer where strangers could easily order a beer and join the crowd.

NEW THEATER

Voice / Communications / Press

We deliberately kept the communications for New Theater opaque. In addition to not releasing documentation of the performances, our emails would only consist of alphabetical lists of names of participants, untethered to their role within the production (unless as author or director), creating a false promise (or intrigue) about who would actually be onstage. Tickets were reserved via email and sold at the door. Every night we would print a basic folded A4 handout with cast and credits.

Design / Online presence

A poster was made for each play, created by an artist, for which we built or found a frame or display case that we would put outside to announce the play. We called them Schaukasten. When the play was finished, we would hang them in the bar. Similar to our plain emails, the website was minimal: it only contained written information about the current and previous plays as well as an image of the current Schaukasten.

Publishing

We never published any books as New Theater. However, upon closing New Theater in 2015 we were invited to stage a play at the Whitney Museum in New York. Because the space had just closed, we no longer felt beholden to the rules we had set for ourselves and the space, and at the Whitney we worked with a mix of New York-based and Berlin-based artists to create a new play. The museum published a book of selected scripts from New Theater as part of this show.

Economy / Resources

New Theater never received any public funds. In the beginning, it was propelled by a small private grant as well as a few of our own art sales. From there, the economics of the space were haphazard. We raised a scant amount in ticket and bar sales, we rented out the space's separate storeroom as an apartment, and we put in whatever money we made ourselves. We also agreed to participate in certain exhibitions because the fee would pay the space's rent. Eventually, we held an online auction of artworks donated by friends, which supported a year of programming, and

QUESTIONNAIRE

as a final fundraising effort we held a rolling sale of poster artworks designed especially for New Theater by friends and artists who had been involved in the space.

Chaotic and exhausting as it was, this all-over-the-place model allowed us a great amount of freedom to do what we wanted with zero pressure about how the money was used (however little it was). The downside was that we were barely able, if ever, to pay anyone. This was a major reason for not continuing New Theater. We tried to reciprocate those who gave us time onstage by supporting them in different ways, providing either our time and energy for whatever they wanted to do at New Theater, or by providing them the space to use as needed.

It's clear that the supporting structures of the art world as we know it are collapsing. Establishing healthy alternative spaces —which can survive in ecosystems outside of grant-pandering and art sales—seems crucial. We have no delusions, however: ours is a model that is far from perfect, but it allows us to be agile, and hopefully it can continue to allow us to form modes of collaborative work into the future.

Duration / Perseverance

We decided from the beginning that New Theater would only be open for two years, and we signed a two-year lease—just enough time to test, to develop, to let go. We closed on a roll—we could have easily programmed another year—but there was a physical, emotional, and financial toll of running such a space for two years. We didn't want to keep going without being able to pay everyone. And we didn't want to get stuck in one form. We wanted to continue to experiment.

Upon closing, we were invited to run the Grüner Salon at Berlin's Volksbühne theater. There is much to say about our psychotic shift from New Theater to a large and well-funded German state theater in the middle of the crisis over Chris Dercon's directorship during the deranged 2017/18 season. We are, and were, attracted to the simultaneous chaos and structure of German theater. For a year, we led the Grüner Salon's program with four of our own plays as well as a performance program focused on Berlin-based artists, attempting to create an artist-run institution within a larger official institution.

NEW THEATER

In 2019, we opened TV, the bar we currently run in Berlin-Schöneberg. It is open regularly on weekends, and though it is primarily a bar, it also maintains a schedule of smaller-scale performances. These performances are often conceived with the artists as series, for example the musician Colin Self's *Clump International* performance nights take place once a month. In some ways, TV picks up where New Theater left off: it is a space that is open for experimentation with performance but on a smaller scale and with less rigidity. Rather than staging our own plays there, we are using it as a set for an ongoing TV series, *Paradise*, the first episode of which premiered September 2020 and that we are still filming. TV is an attempt at creating a space that is able to sustain itself, performers, and our own practice. Relying on drinks sales allows the space to define itself night by night, without a sweeping curatorial gesture. It revels in the fact that an audience doesn't usually question a bar, and we get to build our stories around it, almost unnoticed.

Key artists

There were a few artists who took on several roles in the productions, including Georgia Gray, who wrote and directed the play *DD Mood* (2014) but also performed in several plays and was often also our prop master; Grayson Revoir, who performed in *DD Mood* and *Mercury In Retrograde* (2015), bartended, and built the theater's sound system from scratch; Skye Chamberlain, who built furniture for the space, performed in *The End of Love* (2014), and painted two backdrops; Pablo Larios, who co-wrote two plays (*Farming In Europe* [2013], along with Dena Yago, and *Hotel Moon* [2015]), and performed in *The End of Love*; Yael Salomonowitz, who wrote and directed the play *Spills* (2014), and performed in several plays; Leila Hekmat, who wrote and directed the last play we put on, *Mercury In Retrograde*, and performed in several plays. Standout performances by Alexander Coggin, Lily McMenamy, Mia von Matt, Tobias Spichtig, Karl Holmqvist, Arto Lindsay, Dan Bodan, Trevor Lee Larson, and Scott Cameron Weaver. The list goes on.

Opportunities

We refuse to continue linearly. Every time a project feels like it has found itself and has answered certain questions, we close shop and start over. This doesn't make much sense from the outside. But for us, much of the meaning within these spaces unfolds during the time it takes to build an understanding of the project itself. Once the theater or bar, or whatever, is collectively understood it loses some of its flexibility and power. Every time we start a space we are faced with the fact that we know nothing. Each space has its own gravity. And each of these spaces has provided shifting access points to the city. We are trying to learn how to cast a wider net, and understand the implications.

QUESTIONNAIRE

P!
Prem Krishnamurthy

P! was a quixotic experiment of an institution. The idea to open a space in New York City had been brewing for a while, but manifested itself somewhat suddenly in 2012. By that point, I had run my design studio, Project Projects, for nearly a decade, building deep relationships with artists, architects, alternative spaces, and leading institutions.

STATEMENT

As an exhibition space, P! questioned the commonplace modes of exhibition making and institution building in New York City—particularly regarding approaches to exhibition display and exhibition histories, collaborative roles between artists, curators, and designers, the blurry economic boundary between 'nonprofit' spaces and the commercial art world, and the mixing of different modes and disciplines. The space synthesized years of conversations into a single program. My original mission statement from summer 2012 is worth reproducing here, as it captures the space's ambition, sensibility, and strategies:

> P! proposes an experimental space of display in which the radical possibilities of disparate disciplines, historical periods, and modes of production rub elbows. A freewheeling combination of project space, commercial gallery, and Mom-and-Pop-Kunsthalle, P! engages with presentation strategies and models to emphasize rupture over tranquility, interference over mere coexistence, transparency over obfuscation, and passion over cool remove.

As this mission performed itself, P! underwent several key transformations, evolving with my own thinking and experience. These institutional micro-epochs and curatorial cycles were occasionally called out explicitly, but more often they were internal mechanisms for structuring the program in multiple sequences with an associative logic. I thought of the curatorial program as constituting itself not only within each individual exhibition but also over time through the syncopation of shows. The entire program had a narrative arc, with connections emerging slowly and echoing across years. As an added provocation, midway through its program in early 2015, P! changed its name to K., and began to call itself "a new gallery on the Lower East Side" for a

six-month cycle of fast-paced shows that looked at and performed economic systems. This institutional shift played out the life and death of a New York gallery as a gallery-in-a-gallery.

Some of P!'s key goals were made apparent and others remained intentionally hidden from sight. These goals included: to generate a space in which art, design, architecture, music, and writing could be presented in tandem and on an even playing field; to coalesce a context and audience for experimental exhibition making and display in New York; to challenge and reimagine the outmoded constructs of both the white cube and the alternative space, as well as provide a hybrid example; to intervene within existing modes of institutional communication and mediation; to support and promote the work of key polymathic practitioners, who had wielded enormous cultural influence but without commensurate recognition for their own independent accomplishments; to affect the historical record around the significance and perception of post-WWII design and reintegrate its legacy with that of contemporary art through exhibitions and artwork sales to museum collections; to demonstrate an aspirational model of economic fairness for an independent art space through the establishment of artists' fees; and to create a spirit of transparency about all of these activities to encourage other exhibition spaces. To paraphrase Bertolt Brecht, our goal was to make the world seem a little more habitable every day.

Prem Krishnamurthy

Artists and artwork

P! was simultaneously an artist-driven space and a highly maintained curatorial construct. The program emerged through many, many conversations with others, particularly artists, curators, and writers who helped advise its course—yet at the same time, it was helmed primarily by me. Over its five years, P! followed a strong narrative structure (like an exhibition space as a novel) within its conceptual concerns and sequence of artists and exhibitions over time.

P!'s curatorial approach favored artistic outliers—the things that artists made in their proverbial studios but that didn't necessarily fit into their profile. Within the organization of a show, I also emphasized heterogeneity and juxtaposition of very different kinds of work as well as practitioners, to generate productive dialogue and friction. The architecture and display of an exhibition stood reflexively in the foreground, rather than functioning out of sight. This mode insisted that the framing and mediation of an experience is never neutral, but rather always carries a political agenda. When artists were invited to show at P!, they also understood that they were entering into this specific context, not a white cube gallery space.

The exhibition space

P!'s architecture was itself a project: a work in progress and an active participant in the exhibition program. The space changed between shows, sometimes to the point of being nearly un-recognizable to visitors. Originally, I commissioned the architects Leong Leong to renovate the space, transforming a run-down HVAC contracting office into a functional gallery. The storefront space included two large glass interior windows, which we opted to maintain, and later often used in inventive ways. We ripped out the existing drop ceiling to expose the stained Chinatown particle boards above, contrasting well with the cleanly articulated exhibition walls. Leong Leong also designed an angled, moveable, freestanding wall, which became a kind of "playing piece" in the exhibition space: it could move anywhere within the gallery to transform its feel and provide additional wall surface.

From show to show, I would give participants a near *carte blanche* to edit or change the space, but usually with an accumu-

lative logic. Over time, this resulted in a bright red floor (courtesy of Christine Hill), a doubled façade window (courtesy of Sarah Oppenheimer), as well as a bright green ceiling and foyer (courtesy of Wong Kit Yi and inspired by our curatorial consultation with Mr. Yeh, a Feng Shui master). Some of these gestures were overwritten by future artists such as the HOWDOYOUSAYYAM-INAFRICAN? collective (who painted the entire space in glossy black, but the floor in matte black) and later by Leslie Hewitt (who painted the floor an exact and conceptually determined shade of grey). After this, I again commissioned Leong Leong to redesign P!, transforming it into a self-reflexive take on a white cube gallery space, but with some key details such as a light pink ceiling (courtesy of Martin Beck and Julie Ault) and a cork floor (which was donated by Amorim). This quieter condition lasted for a year and a half. In our final year, we ripped out this cork to expose the original, painted vinyl flooring and reveal the space's architectural shifts over the past five years. This move was mirrored in the installation protocol for our walls, inspired by Betty Parsons Gallery in the 1950s: we painted the walls only once at the start of the year, allowing all of the traces from a year of hanging shows to overlay each other. In both the floor and the walls, the labor of installation, exhibiting, and even visiting the space over time became visible.

Site and geography

When P! opened, the entire block of Broome Street where it was located consisted of Chinese businesses; although people in the art world called the neighborhood the Lower East Side, it was still also clearly Chinatown. In acknowledgment of this dual life and also to provide legibility to its immediate audiences, our initial graphic identity was designed in both English and Chinese. Rather than presenting a neutral, blank façade as most galleries did, we put our mission statement on the storefront window as a Mad Lib with blank spaces for people to fill in. Our press releases were available as handouts from a container outside the door, so that visitors, especially from outside the art world, would not have to ask the gallery attendant for a copy—an art world convention that can be intimidating to the lay person. These press releases were also written in both English and Chinese for our first couple

of years, until the neighborhood's transformations made this (unfortunately) no longer necessary. Overall, we programmed the storefront window as a display in itself—a tableau that offered an aesthetic experience to pedestrians even if they didn't make it through the door.

Our first year of programming responded directly to this neighborhood context, by including participatory projects that engaged with local business owners (Christine Hill), a transforming exhibition addressing questions of gentrification, displacement, and lack of space (*Possibility 02: Growth*), and a six-month cycle of shows (*Permutation 03.x*) seeking to question the power dynamic and implicit value judgments around copying—an explicit reference to the adjacency of Canal Street and its counterfeit goods.

International context

From the beginning, P! called itself a Mom-and-Pop-Kunsthalle (amongst other things). This meant that, in its own small-scale way, it tried to mount exhibitions in New York that could not happen elsewhere. Oftentimes this involved commissioning and presenting the first US one- or two-person exhibitions by international artists, such as Céline Condorelli, Karel Martens, Kate Cooper, Maryam Jafri, Mathew Hale, Michal Helfman, Philippe Van Snick, Société Réaliste, Vahap Avsar, and others. Through my own professional work and travels as a designer, I had the privilege of being involved in or seeing many major international exhibitions and could incorporate this knowledge into the space's program.

At the same time, P!'s program was intrinsically linked to the political currents of the USA, which manifested itself increasingly starting in 2014. A residency at the space by HOWDOYOUSAYYAMINAFRICAN? member Mitch McEwen in August 2014 coincided with the murder of Michael Brown Jr. in Ferguson, Missouri, and a new wave of consciousness around racial inequalities. In response, the Yams Collective created a new installation, *thewayblackmachine*, around media reactions to race and police violence in America—a short but impactful exhibition that eventually traveled extensively. This show marked a turning point in P!'s program.

Audience / Community

In general, I was interested in *hosting*, in its multiple forms.
A fluidity of roles was extremely important to establish. As founder and curator of P!, I often did curate exhibitions, inviting artists and working with them to produce new works or select existing ones and display them. Or I might invite other close curatorial colleagues to organize shows, in which I played any number of roles: exhibition design, graphic designer, producer, or otherwise.

Our shows were, by design, participatory. These ranged from an early exhibition-as-biweekly-reading-group led by artists, curators, and designers, which formed a close cadre of intellectual companions (many of whom accompanied the program throughout its lifespan). Fulfilling our initial promise of passion, P! featured high points such as artist and musician Thomas Brinkmann DJing a record-listening session on his customized doubled-armed turntable with a club-quality sound system to a shoulder to shoulder packed room. Later events, such as a series of discussions organized with Céline Condorelli (and taking place on her custom-designed furniture within her exhibition) dealt with topics such as the politics of display.

Voice / Communications / Press

Our written voice followed a simple set of rules: texts should be thoughtful and analytical, but never jargon-filled. Writing should be as precise as possible rather than making broad claims. Overall, our mediation should be smart yet accessible. I always used as a measure that my sister, who is highly intelligent yet without specific art training, should be able to understand it. We spent many hours writing and editing these texts for accuracy and flow, so that they sometimes became works in themselves.

Yet this voice also changed over time: when P! became K., we also shifted our language. At this point, our voice became intentionally more oblique and abstract, adopting the communications mode of other "cool" galleries as a performative gesture. Ironically enough, this six-month period allowed us to loosen up our communications approach, and feel less of a sense of grave responsibility when writing—introducing a more playful element into our later releases.

At distinct phases of P!, we produced printed matter for exhibitions. This was mostly seen as an artistic extension of the exhibition itself, or sometimes as a vehicle to publish an essay or text which elucidated the exhibition's context (rather than as an interpretive method). These were printed mostly as small-run, print-on-demand publications, or as offset printed pieces in one color.

Design / Online presence

Graphic design was always a self-reflexive part of the curatorial program and intentionally non-monumental. In other words, rather than producing a singular, consistent graphic program, we approached graphic design as a responsive element and also considered a more dispersed mode of communication. In the first two and a half years of P!, we treated each press release as a standalone graphic item. Each one had its own logo or graphic mark for P!, created by an artist in the show, as well as its own distinctive typography and layout, which I designed to respond to the exhibition's content. The only consistent graphic between shows was a textual frame that included our address, email, number, and website. Our business cards appeared to be hand-written, yet were actually printed in letterpress on brown Kraft paper cardstock—mass-produced authenticity. The first website was a repurposed Tumblr site that I designed, so it felt looser and more associative than the usual gallery website. It also contained resources alongside exhibitions including readings, links to other videos, and references. There was no consistent graphic signature; the institution's design was bumpy.

When P! became K., our graphic identity changed accordingly: the gallery "grew up," printed a fancy letterpress card, and designed a pseudo-neutral sans serif press release template and new WordPress website with a lot of white space. This mode of presentation was very stable and authoritative, in order to better insert even more challenging programming into the space—using the visual markers of authority in order to subvert expectations. This approach proved successful in drawing new art audiences who had previously written off P! as a "weird, experimental space."

After K. gave way to P! again, we quietly repurposed the sleek graphics of K. for our final years of communications. In

this way, each phase built upon the last, incorporating its learning into a new whole.

Publishing

We did not produce many publications. This was primarily driven by economic constraints (see next question) as well as bandwidth. Although people often assumed that, as a graphic designer, I would produce a lot of printed matter when creating a gallery, I was more interested in focusing on the space and the responses of visitors in it, physically. That being said, we did design and produce some smaller format, digitally-printed artist publications with artists such as Katarzyna Krakowiak and Peter Rostovsky when it constituted a significant part of their work. Some guest curators, such as Sarah Demeuse, were enthusiastic about conceiving and editing small publications for their shows, which we gladly designed and produced. We also edited, designed, printed, and hand-bound a book about our cycle of shows on copying, which became a popular item and needed to be rereleased as a print-on-demand edition. Later in the space's program, when presenting several shows that intersected with graphic design, we published offset printed ephemeral give-aways—small scale posters with accompanying essays for our Klaus Wittkugel and Maryam Jafri shows, which became nearly collector items due to their small print runs. Roma Publications designed and published a catalogue to accompany our Karel Martens show in our last season.

Economy / Resources

In its final year, I sometimes called P! a 'polemical for-profit institution'. The institution—although it never actually made a profit—was intentionally organized as a for-profit entity, in order to most effectively make certain arguments about economic structures. First, from the start, P! paid artist fees to exhibition participants, in order to recognize and compensate their labor. Even though we were a for-profit organization, we entered into discussion with W.A.G.E. (Working Artists in the Greater Economy) to consider whether a commercial enterprise could also be certified by them. This gesture followed from my experiences as a designer and a recognition that all work should be compensated.

This polemical project also came through in the decision to work commercially. In the financially driven climate of the early 2010s art world, I felt that an effective way to make curatorial arguments about the value of particular practices (especially those coming out of a design context, conceptually challenging approaches that themselves addressed financialization, and the work of certain historically under-recognized figures) was to facilitate their participation in the art market. By ascribing a market value to this work, it allowed it to be acquired by institutions and thereby enter into the historical memory of art.

Through my years of work with both galleries and nonprofits, I also had an understanding that economic structures of both types of institutions are indelibly intertwined (at least in New York City). The donors to many of the most established nonprofit spaces are themselves serious art collectors, with their own agendas at play. Nonprofits must rely on these donors as well as grant funding in order to survive. Working as a commercial graphic designer, I considered it more transparent to function as a commercial entity and simply sell artworks in order to fund our experimental program. This worked more and less effectively at different points of the space's history. For a couple of years, we also participated as a project space in several art fairs (including NADA Miami Beach and New York, Frieze London, Art Basel Miami Beach, and Material in Mexico City) which proved to sometimes be an effective space for creating challenging, standalone displays and demonstrate arguments about art and design, while also generating sales and income.

But in the end, this polemical for-profit was more polemical than profitable: although it did generate income for some of the artists involved, P! lost money year after year because of the ambitious cost of its programming. As I once said to my now wife, "Every month, I take a bag of money and burn it." I covered these shortfalls through my own salary from running a successful graphic design studio, as well as teaching, lecturing, and writing on the side. At a couple of key moments of exhaustion and despair, I borrowed money from my parents to pay the rent and my overhead. A handful of well-endowed collectors gave me small tax-deductible donations through our fiscal sponsor. Overall, this model was not feasible on an economic (or emotional) level,

and was, to be frank, nearly entirely financially and personally ruinous. Although when observed with greater distance, it's probably best seen as an investment in the future: in the artists who were part of P!'s program, in my own curatorial practice and voice, and in the dissemination of the idea that a challenging, experimental, ambitious exhibition space can make an impact on the practice of exhibition making.

Duration / Perseverance

I always knew that P! would end someday, at least in its original form. There was no way for it to sustain itself: its frenetic energy, its fast pace, its intensive curatorial and artistic production, and its financial precarity made longevity impossible. Although I couldn't accurately predict its exact lifespan when I started, it was clear by year four that the experiment would end with the conclusion of our five-year lease on the storefront.

And so P! ended in 2017. This ending also allowed it to have a structure that could loop back on itself, that could mirror its start, and could close with clarity and cleanness. It did continue in another form, when the final show at P!, Céline Condorelli's *Epilogue*, traveled to Stanley Picker Gallery at Kingston University London to become *Prologue*—restarting a chapter, a new beginning to the book. P! also found itself reincarnated in *K,*, the one-year "exhibition making workshop" that I established in 2018 in Berlin with the support of KW Institute for Contemporary Art. This program and ever-changing exhibition functioned in many ways as the *inverse* of P!—slow rather than fast, contemplative rather than hyperactive, focused on production rather than presentation. It was a necessary year to recover from P! and to chart next paths. In any case, P! exists still in many forms—from the traces it left in the world, not the least upon the bodies, the minds, the hearts, the practices of the people who participated in it, including me.

Now, I can say that P!, although originally conceived to be finite, will live on in new forms in the coming years. It will become a polymorphic program, less embodied in one particular space, but still active as an attitude and a structure. Let's see what the future brings.

Key artists

Asking to name a handful of key artists from a five-year program feels like asking a parent which of their children they love the most. Nearly every show was a meaningful milestone, nearly every artist was someone who taught us how to both make work and live in the world differently. P! could not have been what it was without all of them.

To give an incomplete sketch of our scope, including our constant desire to change but also to provide ongoing support to artists' practices, I would first of all highlight our inaugural exhibition, *Process 01: Joy*, featuring Chauncey Hare, Christine Hill, and Karel Martens. It set the tone and approach of the institution, demonstrating a curatorial method founded in juxtaposition of diverse positions from art and design and the gallery's hybrid roles as presenter, promoter, and participant simultaneously. I would equally call out our work with Hong Kong- and New York-based artist Wong Kit Yi, a.k.a. Ali Wong, with whom we first collaborated as a curator and then twice as an artist—Ali's shifting roles and the self-reflexive experimentation of her work were a core stance of the space. I would also mention our exhibitions with significant polymathic figures of an older generation, including Elaine Lustig Cohen, Karel Martens, and Brian O'Doherty; these collaborations allowed us the opportunity to learn from our role models in terms of the inextricably intertwined interrelationships between art and design, artwork and display, while also exposing their work to new eyes. And, finally, I'd include *The Stand* (2017), a sprawling, dystopic group exhibition I curated with the artist Anthony Marcellini. It represented a timely response to the 2016 US presidential election and was enacted through a performative curatorial process.

This also seems like a useful space to mention the *other* people, without whom P! would not have been what it was: Judith Gärtner, David Knowles, and Patricia Margarita Hernandez, who each helped manage and run the space for part of its lifetime. Without these folks, and many others, P! would have just been a bedtime story.

Opportunities

It's hard to self-evaluate here, but I'd answer by mentioning our commitment to challenging ourselves as well as others' expectations, and our desire to pivot and change. Many people use the term "experimental" rather loosely to describe certain institutions, but I think that the term truly applies to P!: we sought to test out different formats and ideas with each exhibition, and then responded accordingly in our program. P! kept moving and transforming, seeking out discomfort, rather than settling into specific norms. This also contributed to its downfall. It's impossible to continue a relentless pace of experimentation and rethinking. And, in fact, "innovation" for innovation's sake can become a trope. It took me years afterwards to learn that there is a place for pacing, for slowing things down, and for sticking to things that you do well rather than abandoning them in the interest of self-transformation.

Here in 2020, evaluating P! and its program from afar, I've realized that the primary reason why I started an exhibition space (or a graphic design studio, a magazine, or any of my other activities) was because of the *community* that is formed. During P!'s lifespan on Broome Street, I knew this but didn't foreground it myself. Although I love exhibitions, it's only now that I fully recognize that I love people more.

QUESTIONNAIRE

Pivô
Fernanda Brenner

Pivô started in 2012 as an artistic initiative with a very practical task: to reopen a 3,500-square-meter space in the Copan Building (one of São Paulo's most iconic buildings, designed by Oscar Niemeyer) after 20 years of closure. For this reason, sometimes I call Pivô a "site-specific institution." The massive mixed-use modernist building in which Pivô is located houses over 5,000 people, and the challenge of figuring out a financial structure that would allow for the space to be continuously open and free of charge is what informed our work methodology, our programming, and institutional thinking. Since we began, we have been working with many artists from different backgrounds and generations, developing proposals that are site-oriented, context-driven, and often the outcome of years of conversation.

A nonprofit space in Brazil is roughly a zero-budget space. In operation for almost a decade, Pivô still doesn't have a stable source of funding (private or public) that would allow for long-term planning or ensure that the space remains fully functional and that collaborators get a fair wage. This instability forces us to adjust and be inventive in order to maintain a consistent, yet fresh, program that resonates internationally and is equally mindful of the local context. We believe in safeguarding a type of quality that follows a logic that is not numbers-driven, which often forces us to grapple with an array of unrealized ideas while also lacking funding. There are no simple answers for this conundrum, but a great deal of the solutions we have found come from a close dialogue with artists and from following their relentless experimentation with how to respond to the here and now.

Art has its own timing, and the production-driven perspective of the art system forces artists to hurry too much. They are expected (and often also want) to provide objects for an increasing number of exhibitions and art fairs, keep updated portfolios, and react to the most pressing global issues in the form of incisive institutional presentations. The essential role of a place like Pivô is to offer support and provide an active space for emerging ideas and help artistic production unfold in all its complexity, allowing artists to truly take their time. In our case, this means orienting our structure to new commissions and research residencies. By doing that, it is possible to interact before the final work exists, and intervene at the stage when critical

reflection can become the basis for engagement, not only within our program, but with the audience at large.

Fernanda Brenner

Artists and artwork

Pivô's program is mostly divided between new commissions and research residencies. Our exhibitions take into account the institution's idiosyncratic architecture and its context when inviting artists to propose new solo projects. This focus, as well as the instability of our funding and the flexibility of our production structure, leads us to create a working method based in long-term relationships with only a few artists per year, thus enabling more experimental and daring proposals that would most likely not happen elsewhere. In our residency program (Pivô Research), we try to actively provide a space for art production and the exchange of ideas, bringing together many artists from different parts of the world to share a work environment for three months. During that time they participate in proposals made by guest and in-house curators as well as in communal activities (some solely within the group, while others are open to the public).

The exhibition space

Pivô has three designated exhibition spaces—one gallery is 1,500 square meters, the other is 400 square meters, and we also use a window display of 60 square meters for interventions by emerging artists. The space is open to the public Tuesday to Saturday, from 1–7pm. We usually organize between four and eight shows per year; the public programs and residencies also generate public activities. The entire space is wheelchair accessible, and we are close to many public transportation lines.

Site and geography

Pivô is anchored in the complex center of São Paulo, where there is a vibrant cultural scene but also extreme social inequality, pollution, and all sorts of urban neglect. Our program doesn't aim to directly reflect these issues, but we try to be engaged with our surroundings in an active and practical way. This ranges from developing a professional institutional structure that employs and creates working opportunities for a younger generation of art professionals (from our permanent team to the freelancers working for the blog, the magazine, or the residency) to creating an ongoing art program free of charge in a place where over 5,000 people circulate on a daily basis. Since its inception, Pivô has

acted in direct response to the needs of the local artistic community while fostering an ongoing international dialogue from this perspective.

International context

We aim to create an open-ended flux of national and international artists orbiting around a steady point—in our case, a landmark building with a very peculiar history. This coexistence of artists, researchers, and curators from all over the world organically prompts important discussions about Pivô's own sociopolitical context, its institutional model in relation to possible international peers, and the reach and resonance of its program. In the end, it is a matter of hospitality and finding the means to provide a space for meaningful exchanges that unfold in an unpredictable, long-term manner. We strive to build an opportunity for *thinking with*, instead of *studying about*.

Audience / Community

We have all kinds of visitors at Pivô, from agents of the local and international art circuit to the tenants of Copan. Our residents are artists and curators (up to 16 at a time, with three cycles per year) who work together in a shared space and receive a lot of visitors during their residency period. Besides those studio visits, we also have frequent participants in our program as well as scheduled professional visits. The studios are not open to the general public, but we hold at least one open studio day per cycle, which generally welcomes around 400 people. The exhibition space is open to everybody and free of charge during opening hours. The public programming of Pivô (mostly talks and workshops) attracts a smaller and more specialized audience.

Voice / Communications / Press

Pivô's voice comes from establishing initial parameters for our program and not being afraid to use the word "institution" from early on; it was always our goal to create a large-scale perennial and autonomous space, which is far from a given in Brazil. Pivô means pivot: we see ourselves as a central axis supporting a revolving scene. Our voice, which we try to keep as consistent as possible, is that axis. We try to convey these ideals through all the

available communication channels—from one-on-one to social media and printed matter, press releases, and our website. All of our written material has been translated to English since the very first show, reflecting the institution's intent to make the content generated by our programs more accessible to international audiences and the other way around, by translating content in English for a local audience. Recently we have been developing special content for visitors with hearing impairment and have become increasingly engaged with their community.

We also have always invested a lot of energy in Pivô's visual identity and printed matter, and the artists often get involved, either by choosing the format, intervening on the layouts, or helping us decide on the content of the exhibition folders. I believe ephemera are a very important asset for historicizing and documenting a time period or a generation of artists. We usually take good care of archiving, documenting processes, and the quality of the installation shots.

Design / Online presence

In my opinion, a strong visual identity is crucial to any institution, no matter its size or typology. One of the first things we did at Pivô was the logo and visual communication, which have hardly changed. We worked a lot with our designers (PS2 design) and some of Pivô's foundational institutional thinking came out of the questions they posed back then. The website is extremely important; even though Brazil is a continental country, it is still quite isolated, even from the rest of South America, and it is also not easy to distribute our content to other states. In order to build a strong local and international dialogue, we conceived the website as an extension of our physical space and as an archive of the content generated at Pivô. Since we often don't find the means to produce print publications, the website contains images and texts from all the shows, interviews, videos, and visual essays, as well as personal profiles of all the resident artists.

Publishing

Pivô doesn't have an ongoing publishing program but this is always on our radar, and we definitely want to publish more. So far, we have published two exhibition catalogues. We just released the

first issue of a magazine, which consolidates and deepens the content of the year's program and that functions as another platform for sharing content produced in the residency program. I edited the first issue of the publication along with curator Camila Bechelany. Besides written and visual contributions from the resident artists, we invited collaborators to produce new critical content in response to Pivô's program and the wider local scene, through interviews, essays, and reviews. The magazine circulated locally and is available at our front desk and online store; we don't have a formal distribution, but it is a goal. We intend to publish one edition per year, always with an invited editor and a roster of external collaborators.

Economy / Resources

In order to operate, Pivô relies on several income sources, none of which is stable. We don't receive any direct public funding (but we do benefit from tax incentives), so we need to fundraise every year. This means constantly finding new (or renewing) connections with private and corporate donors, establishing institutional partnerships, and applying for grants, plus producing and selling artist editions and gift shop goods. We also do an annual benefit and a silent auction, which covers a substantial part of our fixed costs, and we tend to rely heavily on temporary space rentals.

Pivô's long-term program planning is our biggest challenge. We constantly need to seek support to enable new projects by artists we believe in, and to foster curatorial and institutional thinking in an increasingly challenging context. We want to guarantee the quality and the relevance of the content we produce, while providing the artists with the working conditions we find ideal, and therefore need to find ways to properly remunerate our team and keep our massive space fully functioning—this alone is a daily battle.

Duration / Perseverance

We don't have a set lifespan. The project is constantly developing and rethinking its format, but I hope we can find the means and the energy to keep it running for longer in a relevant way.

Key artists

Pivô's 2012 inaugural exhibition was crucial to set the tone of the institution: we invited 14 artists to occupy a huge space that had been closed for almost two decades. The show's title, *Next time I'd have done it all differently*, embodies the trial and error mode that we have adopted ever since. We provided the conditions for artistic dialogue and critical thinking to flourish openly and collaboratively, through commissioning works and enabling residencies. All the artists in this show spent a long time in what used to be a ruin, working together in a shared process mediated by our initial team and the curator Diego Matos.

It's very hard to bring a show that was first assembled someplace else to Pivô, because our space is mostly suited for context- and site-oriented projects. Since that first show, we've invited artists from different generations to create work on-site, thus enabling an ongoing intergenerational and international exchange at the space itself.

The other milestone of Pivô's institutional thinking and programming was the presence of artist Paulo Nimer Pjota in 2013. Pjota makes large-scale paintings and was looking for a space to stretch his canvases and work. We were still figuring out how to occupy this former ruin and operate it as a permanent space, and we welcomed him. He worked next to our office for over six months. Observing the movement around him and the dialogues prompted by his work in progress triggered the idea to start a large residency program. We realized that the way to go was to have a group of artists working there on a regular basis, and to be a space where art is made and shown.

Opportunities

It's an ongoing challenge to occupy a huge and multilayered space with art and artists in a meaningful way. Every artist and curator working at Pivô receives the same "package" to deal with when shaping new work: a potential built-in audience of 5,000 tenants (who don't always come down), the modernist heritage of Oscar Niemeyer (which is like an incidental tune because the space we are in was never meant for public use and has no original, designated program), and the social complexities of central São Paulo. Since the beginning of our operations, we've been

inhabiting and transforming this living organism together with the public and many collaborators, to the point that nowadays we can no longer call it a ruin. We undertook several renovations but never closed to the public (artists did exhibitions in the construction sites), we created programs out of shared experiences, and we have been doing panel discussions with wooden crate seating since day one.

When we started Pivô there was (and there still is) a great need for spaces that artists can rely on to support process-based and more experimental works, or to simply meet and chat with each other. We need spaces in which local experiences and global outlooks can coexist and interact—in Pivô's case, we often have a bias for the local.

The breadth and diversity of practices taking place nowadays requires more speculative and experimental approaches to programming and research, which has always been our key concern.

QUESTIONNAIRE

PRAXES
Rhea Dall
& Kristine Siegel

PRAXES began in Berlin 2012 as a conversation about institutional restraints, the lack of time to experiment and commit, and the sheer, devilish fun of collective discovery. A year later we opened PRAXES Center for Contemporary Art as a nonprofit organization for art and research in a former Brutalist church in Berlin. Between 2013 and 2015 PRAXES presented four half-year cycles of exhibitions, publications, and events, each revolving around two unassociated artistic practices. Every six months, the institution would start with a clean slate, dedicating all walls, voices, and thoughts solely to the work of two artists at a time, who in turn were invited to play the institutional instruments to the tune of experimentation. Instead of idealizing a particular moment in an artistic oeuvre or a notion of retrospective totality, the accumulative cycles at PRAXES attempted to pursue as many perspectives and approaches to the given practice as possible within the time frame. This meant revisiting well-known bodies of work as well as unfolding archived oddities, productive inconsistencies, and blind alleys of unrealized works and abandoned material, but always in close collaboration with the artist.

These sequential snowballing investigations took works of art as a catalyst and prism to draw in an ever-expansive community of experts, former collaborators, muses, colleagues, witnesses, scorned lovers, copycats, critics, and general enthusiasts—some of whom originally came to PRAXES as visitors yet got caught up in discussions, and were invited to speak, write, or participate. Conspiracy-like crossovers, passionate disagreements, and even the occasional magic rabbit hole leading the whole thing temporarily astray made the process attractive—and exhausting.

In 2015, we, as PRAXES, were appointed co-curator of the triennial Bergen Assembly 2016 in Norway. Expanding the experiment from our institutional footing to a perennial art festival, PRAXES developed an episodic and itinerant investigation centered—again—on two artists only. Collaborating with numerous amazingly open-minded institutions, audience groups, and venues to create a yearlong program, the artistic practices at times became a backdrop for other things to radiate, and at times coagulated into stand-alone chapters, connected for persistent local eyes only. Since 2017, PRAXES has been on hiatus—when

your modus operandi is accumulating seriality there is no knowing if you are in an extended interval or at the end.

Rhea Dall & Kristine Siegel

Artists and artwork

Although entering an intense, long-term conversation could seem to predispose or favor practices known from previous collaborations or trusted networks, most artists were neither previous professional acquaintances nor friends when they were invited to PRAXES. Instead, we kept an ever-growing list of artists between us, artists whose practices contained an unusual range of approaches, collaborations, materials, and affiliations. These were people who were unafraid to reinvent their work every so often, and people who we imagine would be interested in—and take something away from—this ongoing questioning of their work. Sometimes it was about digging out a practice that we thought somehow got stuck with the wrong label. Other times, the work itself spoke of alternative temporalities, delays, disjointed intensities—parameters that the institutional practice of PRAXES could learn from.

Yet from the outset we were consciously trying to steer clear of certain pitfalls: catering only to particular audiences or aesthetic expectations, simplifying complex ideas to distill their notions of temporality, the common misconception that time-based exhibitions only deal with time-based media or performance, and that long-term investigations primarily channel research-heavy practices. Of course, choice also came down to schedules and other practical matters—and, indeed, funding. In Berlin, PRAXES did not have the financial means to invite artists based outside of Europe, nor to transport historical, costly work, or to bring in larger groups of collaborators. These parameters changed under the auspices of Bergen Assembly, where the muscle meant we could restage a full 1974 show by Lynda Benglis and host a crew of 1960s seminal, local avant-gardists, art students, and renowned international performers to take part in Monster Chetwynd's (formerly Marvin Gaye Chetwynd) commissioned performance.

The exhibition space

Combing through Berlin's relatively expensive real estate for a suitable space, in early spring 2013 we stumbled upon the two-story 1950s Brutalist-style community house of the former church complex, St. Agnes in Kreuzberg. The intimate atmosphere yet

generous size of the building appeared custom-made for two architecturally distinct spaces, each dedicated to one of the two artists we worked with for the full half-year cycle. Separated on ground and first floors, the building naturally discouraged direct visual parallels or opposition, while supporting chance encounters and post-visit cross-readings. The institutional modus operandi could independently change on either floor without disturbing the rhythm of the other artist's investigation. While opening hours were fairly stable (Wednesday–Sunday, 12–6pm), events and shows were out of sync—instead following the individual logic of each practice, combining long-term, slow-cooked focus with intense bouts of activity. Almost as a retro-spective (introspective and dialectic) taking place over time, the artworks would shape-shift the exhibition space, calling on both previous exhibition histories and the ones created throughout the particular cycle. Placed in the factual center of Berlin (as told by a nearby bronze plaque) but at the time far from the art world's main route, most visitors had to knowingly seek out the institution, while locals passing by would occasionally ask what this "Praxis" (a general medical practitioner in German) would be able to heal?

Site and geography

While Berlin has had thousands of artists relocate there, in the early 2010s it had remarkably few midsize nonprofit institutions with an international outlook and a consistent curatorial agenda, compared to London or New York. PRAXES was shaped along two parameters: the desire for a singular focus for an extensive period of time—to spend some time mining the minds of the sprawling artistic community and the nomadic flux of profes-sionals regularly passing through Berlin—and the drive to address what we perceived as a curious blank space in the institutional landscape of the city.

International context

PRAXES stands on the shoulders of many great, experimental institutions, free academies, and perhaps more than anything, the practices of artists that we always admired for their versatility, range, and ability to reshape their surrounding setups. It was founded after both of us had worked in large, international

museum institutions with full work schedules coordinating and producing simultaneous group and solo shows, editing occasional publications, organizing events, proposing new acquisitions, fundraising, and whatnot, so first and foremost, we were looking for a different way to be in this (art) world. We wanted to avoid being pushed to the mere role of hands-off organizers and to avoid the artists having to be the de facto curators and lonesome archivists of the exhibition history of a given work—as is often the case in the midst of the typically terribly busy and distracted institution. Instead, we longed to start a conversation, in terms of context and content, by staying with one artistic practice for a longer period of time.

The PRAXES invitation, while an admittedly time-consuming labor of collective unfolding and mutual discovery, was made with multiple access points bearing both the occasional visitor and the returning participant in mind. Its critical stance was to insist that it takes time for an artistic utterance to be understood and for its often vast amount of material to settle, for conversations to emerge, for critique to coalesce, and for perspectives to lodge—insisting on taking time.

Audience / Community

The potential of building on serial visits, getting to know the odd corners, digressions, and surprising traits, slowly uncovering the plot, becoming surprised by the rich deviations as the episodes accumulate—these are not only qualities reserved for HBO or academia. At PRAXES, there was not a one-off-and-final finite display (nor a defined audience) but rather a turn of tableaux that proposed very different preferences and, indeed, forms of spectatorship. Sidestepping the global desire to hunt down the new, the young, and the next, PRAXES was created as a collective catalyst for dedicated, in-depth focus and long-term commitment to an artistic practice and its complexities.

This kind of nerdy intimacy resembles friendship, not only towards the artists but also to the artwork and other interlocutors, including the audiences, and also between those alien visitors and odd objects who meet repeatedly, becoming closer. This continuous scrutiny had a fluctuating, but for each artist, loyal sounding board within Berlin's expansive arts community.

The fact that artists could re-install their work in very different ways over time within the same 100 square meters deflated the classical museum's diorama illusion of everything being present and conclusive. Making the spatial construction transparent and bluntly articulating its theatrical premise resulted in loads of comments and lively discussions that we were able to feed back into the programming—some offering expertise and knowledge, others openly trashing whole shows. Obviously both types of responses were very welcome and quite unusual for institutional settings. Over time everyone seemed to get to the point where they were either dedicated or annoyed enough to formulate an informed opinion.

Voice / Communications / Press

The artists that we have collaborated with so far have all shaped the course and voice of the institution as much as we have, if not more, and certainly did so in ways that we couldn't have predicted. Introductory texts were designed in a unique style and printed as handouts for the audience to take home—they were also available online in the same format as part of the *PRAXES Papers* (see below), visually communicating a non-hierarchical spectrum of educational, academic, and artistic thinking and writing.

In addition, the institutional voice was consciously developed to be transparent about the evolving content, and we were constantly reminding ourselves that no e-flux deadline or standard press release should dictate how we would communicate our findings. This speculative roller coaster, somewhere between a honeymoon (constantly in love with the object of desire) and a marathon (constantly committed to the goal), would shape the voice of PRAXES. Trying to look closer, more persistently, and accurately at the practice, while also talking more seductively and enticingly about each position, stayed paramount.

Design / Online presence

The generosity in simple, well-integrated, yet challenging design appears to be similar to the contagious intimacy exuded by a good host: you feel at home but you are intrigued by and attuned to exciting differences. The design profile of PRAXES was not developed as an afterthought to the concept of the institution. On

the contrary, Chiara Figone (graphic designer and founder of the publishing house and exhibition platform Archive Kabinett) explicitly asked to become a close collaborator even before anyone of us knew how much blood, sweat, and largely underpaid years would be involved. Before we had located a site, Chiara dreamt up this institution with us. Her team remained an integral part of PRAXES, always identifying the disparate artistic motifs and rethinking the use of design to any cycle's new organizational relationships. Discussions about the logo, and about the wide-spread idea of institutional brand recognition in the arts, led to a plethora of interchangeable ways of using the logotype, none of them privileged, yet all of them in Figone's straightforward, custom-made PRAXES font. Online, PRAXES aimed to project a sprawling and sometimes even scattered, enthusiastic process of discovery with frequent updates and playful, animated actions such as invitations, installation-in-progress images, and follow-ups to live events. More than a strategy to mirror or promote, practicing collaborative design was a kind of periodical insti-tutional health check of our objectives and their implementation.

Publishing

PRAXES produced a series of free publications, titled *PRAXES Papers*, specifically designed for online viewing and downloading. Concurrent with each six-month exhibition cycle these pub-lications became available step-by-step as PRAXES commis-sioned, collected, and edited material about and from the artist in question. Some *Papers* were written on request of the curators and artists to cast light on a particular aspect of the practice or program, others were out of print essays often either annotated or illustrated, archive drawings animated for the online format, live talks transcribed, old interviews with added commentary by the original participants, artworks with captions transformed daily, academic overviews of historical contexts for particular works, poetic readings of titles, and a number of other experiments. Some of these *Papers* have print editions, and there was always an institutional desire to return to this vast material as well as the expanded, playful format to develop it further. The *PRAXES Papers* are edited by Cassandra Edlefsen Lasch and us, while Chiara Figone of Archive Books is responsible for the graphic design.

Economy / Resources

Like many nonprofits, PRAXES was built and largely run by an extended network of underpaid, overqualified professionals and enthusiastically supported by their non-professional friends, families, and any distant cousin who could drive a van to pick up a borrowed projector. The institution received a couple of crucial start-up grants from state funding bodies and local private foundations as well as smaller donations from private donors, some through a crowdfunding campaign. Embassies, galleries, and local companies would occasionally provide in-kind sponsorships. Perhaps the largest indirect contribution was that our salaries, i.e., the directorial pay, as well as the salary of the chief editor, were covered by positions held concurrently at other (research) institutions, and thus the organization prioritized paying assistants and gallery attendants (although their skills called for better compensation than what they got).

The constraints of this precarious model were many; work hours spent vying for possible donors, writing applications, and worrying were cause for a constant energy deficit. While there were significant freedoms to be explored in the curatorial/ organizational model of PRAXES, it feels contrived to speak of freedom in the financial model of PRAXES. Any real sense of economic independence dissipates when minimum operational funding can only be guaranteed six months ahead. In terms of fiscal sustainability, it was a strained, laborious affair against the odds that everyone entered with open eyes yet not without serious leaps of utopian optimism.

Duration / Perseverance

Two years in operation and eight cycles in—each costing as little as a minor group exhibition in a major institution in Berlin—and with pounding and energetic support from our co-conspirators, the impoverished Berlin art community, and international peers beyond this geography, we had not received any public German support. At this point, the project became endangered. We were pulling out hair in frustration and even putting in our own money when none was left. The question if Berlin needed a different space for collective exhibitions and thinking was, despite the local and international community's uplifting backup,

responded to by monetary supporters with a resolute no. Similarly, we asked ourselves if we could ethically continue beyond the start-up margin of two years with no stable backing, without paying salaries to staff beyond our assistants, which we decided we could not. PRAXES would have to fold or transform itself, becoming part of other communities, and nomadically keep moving. And so, we left Berlin.

When we moved to the rain-drenched periphery of Europe to co-curate the Bergen Assembly in 2016, PRAXES got a second life. Thus, we were able to extend the cycle to a full year; to try out seriality in different locations; and to commission large-scale new work. In its entirety, this experiment counted three years.

Key artists

From 2013 through 2016, the cycles we mounted in Berlin focused on Jutta Koether | Gerard Byrne; Judith Hopf | Falke Pisano: Matt Mullican | Christina Mackie: Rimini Protokoll | Chris Evans; and henceforth, in Bergen, Lynda Benglis | Marvin Gaye Chetwynd. Rather than a symmetrical pair similar in style, the different positions were chosen to tease out very different interests and summon a variety of communities. Often parallel cycles were out of sync since the number of displays and the tempo and timing were cued by the particular artistic work in question. The aim was to make the idiosyncratic artistic utterance the basis of how the institution would work, changing its modus operandi for every artist's cycle.

Jutta Koether's cycle, for example, was constructed around a new triptych that on her initiative was torn apart and presented in three independent sequences. Meanwhile, during opening hours the staff was instructed to add and remove older works, creating a constantly shifting "show." Inspired by Jutta's performative painting practice and its ability to stay liquid and in dialogue through multiplying and transitioning motifs, the objective of this ever-turning display was for each part of the triptych to encounter peers from Jutta's extensive back catalogue.

Gerard Byrne's cycle was constructed as a five-part theatrical play, each with different stage sets of spotlights and media works; a pretend (but not entirely chronological) retracing of his oeuvre with the titles *Recent works*, *Older works*, *Early works*,

Around that time, and *Just before that*. The five-part play was directed with a master script constructed as an old-fashioned TV schedule, turning different works on and off at set hours, and theatrically (re)enacting or (re)playing the works in new runs. Changing the exhibition experience every day emphasized how any viewing moment is connected to a political, physical, and social context. In this, the exhibition itself mimicked how Byrne carefully turns the prism of historical moments through reenactments in his video works.

Doing consecutive shows by the same artist, we were able to include works that only came to mind and gained significance through this process. Jutta unexpectedly pulled out two uncataloged works from the early 1990s—both leaning on Gustave Courbet's painting of the female sex, *L'origine du monde*—as we approached her final show centered on a gouache of a large erection. Gerard, on the other hand, rediscovered an early 16mm film restaging an even earlier performance by his twin brother, doubling the double in the last exhibition module of his cycle.

Opportunities

PRAXES was always a weird Trojan horse. We spoke about it as having a slow-cooking long-term focus, yet we have never worked harder or longer hours. We both built the horse and let it fool us—so there you have it! If we could go back and enjoy the ride even more, we would remind ourselves that easydoesit; big picture beats getting all the details checkmarked. Beyond that, PRAXES today feels like an experiment embedded in the 2010s; it was a confrontation of systems and infrastructures internal to the art world, aimed at tweaking its existing mechanisms and expanding them. Of course, the main experiment was always to find satisfying, investigative ways to work with the most magnificent artists we could dream up, together. Looking back, it feels like exploding the mechanisms of any so-called art world might be even more pertinent, moving the focus from "how" to operate, to "for whom" and "with whom"—changing the communities and voices engaged. But at the end of the day, the real satisfaction was in the intimate, delicious encounters with art, artists, thinkers, and audience members, in the collective

experience of wholeheartedly diving into a practice and letting it wash over you.

RAW Material Company
RAW Team

RAW Material Company is a Dakar-based center for art, knowledge, and society. It was founded as a project in 2008 before becoming a physical space in 2011. Our founding director Koyo Kouoh responded to an urgent need in Senegal for a site of critical reflection on artistic practice and its symbiotic relationship with society. While Dakar was already renowned for its biennial and lively artistic scene and history, there was nowhere in the city to explore, discuss, or expand on art as being generative of knowledge in relation to the most pressing societal issues of our time. It therefore became paramount to build an independent institution that could contribute to reformulating society's relationship to art, not only in Dakar but in constant collaboration and dialogue with the rest of the African continent and allies across the globe.

We are involved in curatorial practice, public forums, residencies, knowledge production, exhibitions, symposia, and international collaborations, as well as artistic education through our RAW Académie, and the archiving of theory and criticism on art. RAW's program is transdisciplinary and is equally informed by literature, film, architecture, politics, fashion, cuisine, and diaspora. It works to foster the appreciation and growth of artistic and intellectual creativity in Africa.

As of October 2016, after five years of intense exhibition making, RAW Material Company made the decision to channel a greater proportion of its energies into artistic education, recognizing that healthy and fruitful art making and display in our context had to go hand in hand with support for an emerging generation of artists, curators, art historians, and critics. Our extensive research and deep study of the landscape of art education in Africa and beyond, including the groundbreaking 2014 symposium Condition Report on Artistic Education in Africa, led to the inception of RAW Académie which ran its first session in late 2016. We strive to make visible the highest standards of inquiry and creativity that exist in Senegal, and to bring comparable practices from further afield into dialogue with our environment while being open to new models of institutional practice in a quest of constant trial and error.

RAW Team

STATEMENT

Artists and artwork

There have been two principal chapters in the life of RAW that engage with the work of artists in different but connected ways. From 2011 until 2014 RAW organized regular exhibitions featuring work by artists who have been committed to building new ground for society and reflection, or whose work proposes insights into contemporary issues. Our residency program, organized through an annual open call, has existed since 2011, and has welcomed over 40 artists, researchers, and curators from around the world with whom we work very closely, and who bring new perspectives to our environment. After taking an institutional sabbatical in 2015, we reopened in 2016 with a shift in programming towards our RAW Académie. The Académie allows for a different type of work with artists, prioritizing their role in research and new ways of thinking while creating a platform for them to share their methodologies and questions with younger, emerging practitioners from various artistic disciplines. We select the Académie directors based on their unique way of working. In turn, they then invite the faculty members, and together we select the fellows following an open call.

The exhibition space

RAW has a very flexible space that is centered around a fairly classic white cube that we can transform according to our programs and exhibitions. We also have two outdoor spaces that we regularly use for our public talks and Académie sessions. This malleability means that we have the scope to show artworks in high-tech conditions but also in more idiosyncratic ways, depending on what the work demands. We initially wanted the space to be a blank canvas (hence the white walls) during each Académie, but we recently started to introduce color even outside of exhibition periods. This intervention sets the tone for each program. We also have a separate residency, Kër Issa, which is a 20-minute walk away.

As of 2016, our annual calendar usually involves two Académie sessions, one or two exhibitions, weekly public talks, film screenings, debates or artist talks, two residency cycles, and multiple collaborations abroad. The space is open to the public 12–6pm (while working hours normally stretch much longer,

and often into the evening). Our library is open to the public on weekdays and Saturday mornings, and we extended its space in 2019 to accommodate the growing collection and welcome more users!

Site and geography
RAW Material Company inhabits a former family villa in Dakar's midtown. To the west, it borders the university campus and to the south more working class neighborhoods. As is the case for most of the city, the neighbors know one another and it has been generative to get to know them better through our different projects. When doing research for a project on the May 1968 protests in Dakar, for example, we learned that the high school at the end of our street was one of the first in the city to strike in solidarity with the university students. What's more, our monthly Citéologies program that explores issues of urbanism in Senegal and Africa, has provided a fruitful way of getting to know different local stakeholders. It has also served to give them a different platform of expression and exchange. In terms of context, we elaborate our weekly programs with specialists in Dakar in the fields of cinema, visual arts, architecture, and social commentary. Thinking more broadly, RAW is informed by its immediate surroundings, while also remaining responsive to and active in more international fields of thought and production.

International context
We are deeply engaged in lines of inquiry and current and historical events on the African continent. Through our programming we search for responses within and beyond our context. While all countries and regions have their specificities, we share the experience of "digesting" colonialism with the rest of the continent. A central concern of ours is always how to support a healthy arts sector; our Académie is very much oriented to young practitioners from Africa, where there is a general lack of formal artistic, curatorial, or art historical training. We are also members of Arts Collaboratory, a trans-local network of independent art organizations working for social change principally in Latin America, Africa, the Middle East, and Asia. Within this network we participate in working groups, develop curatorial projects, and

engage in moments of deep study around our different practices. This collaboration functions as a longstanding commitment to international solidarity, which we have also explored in numerous curatorial projects and our residency program. Several projects have served to unearth forgotten or hidden narratives that challenge mainstream ideas around the way peoples interact with one another beyond the lines drawn by colonial powers. A recent collaboration with Vietnamese artist Tuan Andrew Nguyen, for example, explored the legacy of the Indochina war through the experience of Senegal's Vietnamese community.

Audience / Community

The line between audience and participant is blurred for us; "community" might be a better way to describe how we approach our relationship to others. Within a community, different members are active in different ways and at different times, and we are one member among others. For example, our 2019 exhibition *PO4 (Blackout)* with Danish artist Christian Danielewitz brings together global environmental concerns around phosphate mining with an attempt to address pressing local needs. For this project, we partnered with two Senegalese experts in activism and good governance to organize a series of workshops for environmental activists. We often approach a subject in a similar way: our public programming opens up access to the work we are engaging in and gives our local audience an opportunity to question and debate the practices we share, while the broader themes of each program speak to urgent and necessary questions on a global scale.

Voice / Communications / Press

The voice of the institution is formed through the richness and diversity of its programming. Our press releases exist first and foremost to share information about our events on a larger scale and to reach a wider audience. Our communication materials are bilingual (English and French) so as to reach our local and international audiences. For our exhibitions, we print invitation cards, posters, a banner for the building's facade, a wall text on vinyl, a booklet, and a more extensive catalogue. For the RAW Académie, we also distribute information flyers in other cultural

spaces and sites of higher education around Dakar, to ensure the information reaches people who may not be aware of the program or our existence. We want to share information more widely and foster a better understanding for our visitors.

Design / Online presence

Above all, we strive for simplicity in our visual communication. Our design is sober, straightforward, and easy to understand at first glance. We also aim to give our audience as much information as possible about our programming. As such, we include narrative text as well as participants' biographies in the descriptions of our events, whether it be for social media or for our webpage.

Publishing

Publishing books and publications is a central part of our mission. Since we opened, we have published more than 10 books, with two more joining the roster in late 2020 and early 2021, as well as a series of smaller publications. The books (exhibition catalogues, collections of essays, proceedings of symposia, etc.) are edited in-house, sometimes in collaboration with other publishers and/or institutions (Hatje Cantz, Sternberg Press, Motto Distribution, WIELS, Deichtorhallen, OCA, EVA International, etc.). We are very faithful to our beloved graphic designer Rasmus Koch studio, although we have collaborated with other graphic designers on different projects. It is extremely helpful to work with someone who knows our work and our ways of working so well.

The books are distributed by the publishing houses and institutions we collaborate with, but are also available at RAW Material Company and during our events in Dakar (and around the world!) through pop-up bookstores, and we also sell a number of our publications online. We are currently developing a better network of distribution through partnerships with friendly institutions. We would love to have our books more easily available on the African continent, but it's complicated to establish publishing and distribution networks.

Economy / Resources

RAW Material Company has been funded in several ways since 2011, but we always avoid the pattern of responding to grant

QUESTIONNAIRE

opportunities handed out by development agencies or foreign cultural institutes with a particular political agenda. This kind of funding model is prominent in our part of the world and unfortunately encourages organizations to jump from one project to another to keep up with thematic priorities defined elsewhere. While we understand that these grants are a necessity for many, at RAW we are committed to entering into multiyear partnerships with our funders, which allows us continuity, the opportunity to grow, and the space to reflect fully on each aspect of our program.

It is also important that our funders understand and support our vision, and are willing to experiment with us. One example is Arts Collaboratory, funded by DOEN Foundation, where we actively attempt to change the nature of donor-beneficiary relations. For specific projects we may solicit or receive one-off funding, if necessary. We are increasingly asked to work on shows or collaborations as an institution and while this revenue would not support our survival, it is a useful opportunity to reflect on the potential monetization of our labor and skills, which comes with advantages and pitfalls, of course.

Duration / Perseverance

We celebrate self-reflexivity, and we constantly question the necessity and relevance of our work, which in turn defines our programming. We observe, experiment, reflect, and adapt; the clearest example is our institutional sabbatical in 2015. RAW Material Company is now in the third "chapter" of its life. During the first chapter, our programmatic focus was exhibition making. As of 2016 the RAW Académie has been the central node of our work, representing the second chapter. We continue with this programming but since 2019 have undergone a structural shift, as our Founding Artistic Director Koyo Kouoh took up the position of Executive Director and Chief Curator of the Zeitz MOCAA museum in Cape Town. This transition is significant; we, and particularly Koyo, recognize that RAW Material Company should be given the chance to have a life independently of its founder (and, inversely, its founder should have a life independent of RAW). Since our genesis, nurturing the intellectual and professional growth of the team has been a priority, because this in turn stimulates the intellectual and professional growth of the institution.

We are excited to continue the journey in new waters for as long as we feel there is a need for us to exist. In the context of Dakar there is still a dearth of spaces working in the field of critical knowledge production around art making; we certainly feel a commitment to keep working, and to persevere in supporting our creative community for the foreseeable future in any way we can. We work in relation to the society within which we exist, and from where we grew. Our lifespan will largely depend on how this relationship evolves as the society around us changes, and as we change alongside it. It's thus crucial to consider the interplay of the institution and the individuals who work there: without people there is no institution, and the institution necessarily takes on the positions, interests, and idiosyncrasies of its team at any given time. The institution, however, must be able to survive after their departure—perhaps what remains then is a commitment, a set of principles, and the very openness that allows for such change.

Key artists

In 2018 we worked on a multi-pronged program which took place leading up to and during the Dak'Art Biennale. This is somewhat representative of how different aspects of our work are woven together and feed into one another, and how different localities and scales of thinking come together for us. Focusing on the May 1968 global student protests, and the general strikes at the then University of Dakar in particular, we set off with Frida Robles Ponce—a RAW Académie alumna who had already worked on the site—on a path to understand the aesthetics of this revolt. This project came together in a number of ways, through a series of public talks exploring the enduring crises of the Senegalese university system, with protagonists from key moments in this history; a small archival exhibition showcasing songs and Senegalese reviews and journals from the post-'68 era; a sound installation at the university, developed with Frida Robles Ponce; and an iteration of the exhibition *Seismographies of Struggle,* curated by Zahia Rahmani.

Opportunities

The human, and human relations, are the bedrock of what we do and how we keep going every day. We try to never forget this and, as much as possible, we build structures that support those relationships in a respectful, empathetic, and hospitable way. Having said that, while we have a solid grasp on how to work with people, we could improve our work around nature and the way that we respond to the climate emergency, both in our programs and the way that we physically function and use our space.

RAW is an all-female team. This often strikes people as rather idiosyncratic, while it is a somewhat extreme version of a reality in the cultural sector where women make up the bulk of the workers and are historically underrepresented at the level of leadership. Within our institution we are able to create every day our own small feminist utopia, which is rather marvelous for a young team that then moves forward less resigned to facing sexism in the workplace.

Since the beginning we have consistently created space for the visions of our friends, colleagues, and community. Some of our weekly programs, such as vox-ARTIS, have been running since RAW's early days and have been developed with our local program contributors: Massamba Mbaye, Ibou Fall, Carole Diop, and Abubakar Demba Cissokho. The RAW Académie is an example of this on a larger scale, where the lead faculty of each session gets carte blanche to develop the program as they see fit, and which then shapes the entire institution, not just for the seven weeks of the session, but beyond it, too.

QUESTIONNAIRE

Signal
Elena Tzotzi

Every day, we calendar our minutes ad absurdum,
yet we feel constantly behind schedule.

Every day, we process a massive overload of information,
yet we never feel updated enough.

Every day, we connect to the whole world and beyond,
yet what we most desire is to be fully right here, right now.

Every day, we are reminded that this constant rush
is not what we dream of, that something needs to change.

STATEMENT

Founded by artists in 1998, Signal is a center for contemporary art in Malmö, Sweden. Early on, it organically formed into a group of artists and curators led by a desire to explore the meaning of collaboration and curation, to support artists, to propose new modes of production, and to stimulate the ongoing public discourse around art.

Today, Signal is the sum of the people that have been and still are involved: since the beginning, Christian Andersson, Maria Bustnes, Alexander Gutke, Sara Jordenö, and Magnus Thierfelder; then Evalena Tholin, Elena Tzotzi, Johan Svensson, Emma Reichert, Karlotta Blöndal, Luca Frei, Runo Lagomarsino, Johan Tirén, Carl Lindh, and Fredrik Strid; and more recently Joel Odebrant, Matthew Rana, Kah Bee Chow, and Olof Nimar.

Our mode is slow and rugged, infused with humor. Our vision is to push ideas forward in dialogue with tenderness and sensitivity. Our home is our space, with one foot firmly rooted in Malmö and the other outside, maintaining a physical presence that is welcoming and intimate.

Stepping into our third decade, we haven't cracked the time riddle. Yet we continue to develop a tempo and rhythm that allows for a deeper search—determined to walk with time on our side, and to cultivate the pleasure of staying with the now in all aspects of artistic process.

We wrote this statement in the beginning of 2019. We had just celebrated our 20th birthday and the one question that occupied our minds was what kind of future we wished for. The whole world, and the art world in particular, was turning in such a speedy and unsustainable way. Everything was just scrolling by—shows, artworks, ideas, information—yet the feeling of intellectual and physical exhaustion was depressing.

We wanted more than that, but of course we had no idea what was coming.

Then 2020, "the lost year" of the Covid-19 pandemic happened, a year that did not rush by. Despite all the hardships and uncertainties, 2020 offered an unprecedented collective moment to reconsider time and timing, to be reminded not to take things for granted, and truly reflect on what really matters and how we want to shape our futures. Our program for the year did not turn out the way we had planned it; in a way, it turned out much better. A three-month exhibition project transformed into a yearlong exploration of artistic collaboration, dedicated impro-visation, and huge amounts of trust and continuous commitment from the artists involved. We could not have treated this year in any other way. We learned to stay with the meandering process of exhibition making and enjoy giving it even more time than before. We're committed to slowing down the pace and engaging in fewer, yet fulfilling, projects. This is a challenge worth exploring.

Elena Tzotzi

Artists and artwork

Signal's curatorial practice comes out of a continuous collaborative and collective dialogue where we share our thoughts, concerns, and desires. It always begins within Signal and then extends to the artists we invite and work with. When researching and composing our program the guiding principles are to be curious, surprise ourselves, and have our process be inspiring. This often leads us to artists we don't know personally, so each new collaboration can be challenging for both sides. You really need to get to know each other to understand each other's working method. Creative disagreements can only be productive when handled gently and with true commitment to each other's integrity and practice.

We see our exhibitions and projects at Signal as genuine collaborative undertakings that blur the conventional lines between institution and artist. This process is not always the smoothest, though, because it requires much time and it definitely requires reciprocal trust. You are in a vulnerable position when you share unfinished thoughts, but when the sharing is mutual you can reach far beyond your individual thinking. To us, the key issue is to carefully listen to each other's intentions and to be attentive and fully engaged.

The exhibition space

Our exhibition space is our home. We treat it with much love and care because we want our guests to feel the most welcome. This translates into our space being a tool that has the ability to transform in order to accommodate each project in the best possible way, whether this is related to questions of organization, architecture, or opening hours. We prioritize fluidity instead of a fixed frequency in our program. This way, each project can take the format it needs—from an exhibition to a series of performative events, to operating as a cinema, etc.

We are now in our seventh space. Each move, mostly because of rising rents, has also sharpened our ability to think and plan spatially in order to maximize each square millimeter we have at our disposal. In our current home of 120 square meters we have built an exhibition space, a library/small auditorium (for talks, film screenings, meetings, etc.), an office space, and a storage

area, creating a seamless web of everything we need to run our program.

Site and geography

Malmö affects Signal, and Signal has a considerable effect on the art scene of Malmö. Signal has been able to survive economically, and slowly explore and develop its own curatorial voice, precisely because we are located in Malmö where living expenses, rents, and other services are much cheaper than in the rest of Sweden. Despite our modest funding, we have been able to perform at a very high level of uncompromising artistic quality. And because we are not operating in Stockholm, the epicenter of the Swedish art scene, we have not been absorbed by the power plays that naturally take place in a capital city where the concentration of power and money can be disorienting.

Operating from Malmö, the Swedish south, our geographical proximity to the rest of Europe has naturally nurtured an international network, even more so than a national one. Malmö is a city much influenced by its industrial working class history and its culturally diverse present. It is a place where nothing is served for free or taken for granted, which has formed a strong do-it-yourself/do-it-together mentality, and a sense of community across all cultural fields. Although the art scene is vibrant, it is also very fragile. Small changes in the infrastructure have large consequences—if a space opens (or closes) the impact is substantial; if people move in (or out) their presence (or absence) is greatly felt. Because of these conditions, we have always pushed ourselves to perform our best, as if our existence depends on it, and to support and encourage other initiatives.

International context

From the very beginning Signal has had one leg in the international context, and the other in the local. The art scene of Malmö is rich and exciting, but because we are not a capital city, the chance that Malmö-based artists will be noticed and picked up by the international art circuit is reduced. We are well aware of this fact and make a point to bring artists from various geographical and professional positions together, thus not only creating an exchange but also helping to spread a larger awareness around

practices operating out of Malmö.

It is important for us to follow what is happening internationally and locally in order to respond to the issues we might agree or disagree with, whether they are of an artistic or political nature. This is how we formulate our position and sharpen our voice. We find joy in being inspired by collegial spirits (spaces, artists, curators, etc.) and borrowing freely from what triggers our attention, but we never just reproduce. We always aim to connect with our own specific local context from which it makes sense for us to speak. One such example would be the solo show *Spelling* we did in 2016 with Guadeloupean artist Minia Biabiany, where the little-known fact that Guadeloupe had been a former Swedish colony was addressed, among other things. Another example is the 2019 group show *Our friend, Valerie Solanas* with Ellen Cantor, Chiara Fumai, Pauline Oliveros, Carole Roussopoulos & Delphine Seyrig, which was a direct response to the patriarchal structures and sexual abuse of power manifest in all layers of society.

Audience / Community

Our audience is quite diverse, ranging from the highly aware art professional to people coming in from the street. Yet we treat all visitors as our extended family, some of whom we know well and others we meet for the first time. We want people to feel welcome and invited to engage with our program because Signal is interested in shared thinking. As curators we create the program and we are also the ones greeting you at the door; there is an immediate and direct exchange between us and the public. We are never the sole experts of our program but together with the audience we engage in a two-way learning process. We explore matters—from a specific artwork to broader, current concerns—in dialogue and always with a curious approach to each visitor. The best outcome of shared thinking is when our visitor becomes a participant, contributing to the program through related events or partaking in future exhibitions.

Voice / Communications / Press

Finding our own voice is a quest. It is not always an easy and evident process, but we make a point of enjoying it. We

deliberately stretch our language to avoid the formulas of promotional press releases and generic exhibition texts. We don't do this because we like mannerisms, but rather because we strive to get closer to the art itself without simplifying it. In a way, this linguistic quest is similar to exploring and getting to know your own vocal cords. The more confident you get, the more you dare to explore the outer limits. We don't want our voice to be a fixed voice. It is more of a tone and an approach that allows for humor, seriousness, and dreaming all at once. We treat each exhibition text differently, as a specific ingredient that goes into a particular show. We never just explain: we might provide context, trigger associations, or simply just tell a story. The text is always a companion to the exhibition—never a manual.

Design / Online presence

We like to do things with a resourceful simplicity—we never aimed for a consistent graphic identity, for that matter. Our logo has changed quite organically 4–5 times since the beginning, mostly out of curiosity and desire. We have worked with a number of graphic designers on different occasions throughout the years, and sometimes we have done the work ourselves. Depending on the nature of each project and its needs, we always engage in a close creative dialogue with the designer on how to "solve" matters of design rather than handing over a task. We like to be closely involved in all choices and think together. Overall, we put much more care into our physical presence than the online distribution of images. That said, we mainly use our website as our own archive and a space for sharing all the amazing material that our invited guests have gifted us: works, talks, readings, and performances. It is our very own eclectic public library.

Publishing

We put all our focus and resources into our exhibitions and the events that accompany them. There is a beauty in the ephemeral physicality of an exhibition. You put so much attention into every minute detail, and this is something that needs to be experienced with the presence of your own body. With our exhibitions we construct narratives that unfold beyond words. Persistently and unapologetically we prioritize spatial thinking and reading that

can only be experienced on-site, despite continuous requests of whether there is a catalogue to go with the show. When we have worked with books they have been more like artworks: an artistic idea that is best executed within the possibilities and the constraints of the book.

Economy / Resources

Signal started with a zero budget and it has been a long and demanding journey to reach the point where we are today, twenty years later. We are now funded by the Swedish Arts Council, the Culture Administration of Region Skåne, and the Culture Department of Malmö. Although the funding is still quite modest compared to our actual costs, it allows us to run Signal on a set of values that recognize and support all aspects of artistic production. From early on, it was important to treat our invited guests the way we would like to be treated. We therefore took artistic production, fees, and costs very seriously and always tried to cover those. We became resourceful in doing a lot with almost nothing, and we continue to nurture this ability. Running an independent space will always be precarious and fragile, but we are free to formulate and realize our own program without the interference of the market, a board, or bureaucratic guidelines. This is our specific freedom, and without it there is no point for us to continue.

Duration / Perseverance

Signal has never had a set lifespan, and we never know how long we will last. Things happen, life happens, so we need to play it by ear all the time. As long as Signal feels like a companion to all of us involved, with whom we grow and develop collectively and individually, it is worth everything. It is an independent, uncompromising, enthusiastic, and at times quite demanding force that we have cultivated slowly and methodically. Signal is knowledge that we have gained collectively through hard-earned experience and a way of doing things from the heart.

Key artists

Every single artist, exhibition, and project has entailed a deeper understanding of how we can push things further and sharpen our

mission. Even when projects have not turned out the way we wished, they have provided vital insights into the mechanisms of artistic collaboration and the art world at large.

Our most recent project, *A Malmö Trilogy* (2020) with Selma Sjöstedt, Angelica Falkeling, and Sara Lindeborg, took on the format of an exhibition trilogy. We wanted to explore a number of questions: how can we as an art institution encourage and stimulate a meaningful exchange between artists as colleagues instead of competitors; how can we help defy the imposed limitations of a signature style in favor of artistic experimentation; how can we challenge the understanding of what constitutes a successful artist career, nowadays defined by the art market, fellow art institutions, and even art academies; how can we act on the structures, and not just the choices, we make? To this end, we invited three artists who had not previously worked together to tell one exhibition in three consecutive chapters. Each chapter had a leading voice and was the sum of a collaborative exploration of the multiple folds that compose an artistic practice. To the surprise of many, each exhibition chapter, despite being conceived by the same three artists, turned out very differently. By the end of the trilogy there was a sense of mutual satisfaction, to have been given the opportunity to dive into an artistic practice both as colleagues and as audience.

Examples of our solo and duo shows from the last decade are: *Dark Spring* (2019) with Johanna Arvidsson, *The Fort* (2015) with Allison Smith, *Occult Geometry* (2014) with Jennifer Tee, and *Drumming like a woodpecker* (2012) with Latifa Echakhch and Charlemagne Palestine. Group shows include, among others: *To the east and to the west, two planets appeared on the horizon* (2018) with Francis Patrick Brady, Jeannette Ehlers, Jacob Kirkegaard, Iman Mohammed, Karin Tidbeck, Andrzej Tichý; *Digital Distress—Consumed by Infinity* (2017-8) with Kah Bee Chow, Andreas Kurtsson, Alexandra Lerman, Adriana Ramić; *with wounds of clarity / with wounds of dust* (2017) with Beatriz Santiago Muñoz, Emil Westman Hertz, and chants by María Sabina; *...this is Radio Athènes* (2016-7) with Eleni Bagaki, BLESS, Rallou Panagiotou, Vangelis Vlahos; *Something eerie* (2016) with Lawrence Abu Hamdan, Graeme Arnfield, Ieva Epnere, David Kasprzak, Daria Melnikova, Tadasu Takamine; *Reading "The World in Which We*

Live" (2013) with Dan Graham, Camille Henrot, and a herbarium by A-L. Löfberg; and *A Parallel History—The Independent Art Arenas of Skåne 1968–2008* (2009).

Opportunities

Signal is about creating, conveying, and sharing a feeling of solidarity. The intuitive aspects that make up the life and existence of Signal cannot be listed as a manual—it is a way of being and of doing things out of love, pleasure, and joy. In this respect, we feel a strong resonance with the beautiful words of Josh Madell, co-founder of Other Music: "Music, you know, it's a way to connect with other people, it's a way to connect with yourself and just kind of live for a purer type of joy than we get in our daily grinds."

Sørfinnset skole/ the nord land
Geir Tore Holm
& Søssa Jørgensen

In 2002, the county of Nordland initiated Artistic Interruptions, a public art project led by curator Per Gunnar Eeg-Tverbakk. The two of us, both artists, were invited to present a proposal for the old school at Sørfinnset in the municipality of Gildeskål. In turn, we invited artists Kamin Lertchaiprasert and Rirkrit Tiravanija, founders of the land foundation in Chiang Mai, in northern Thailand. We were inspired by their philosophy around the local, social engagement and ecology, and their nonprofit attitude. The initial idea was to make a sister project, which is why we titled our collaboration *Sørfinnset skole/ the nord land*. From there, *Sørfinnset skole/ the nord land* was born.

As a project, *Sørfinnset skole/ the nord land* emphasizes dialogue, engagement, and experimental forms of value production while connecting different traditions and experiences. We research ecology and natural habitats in a broad sense through season-based activities, such as small-scale experimental architecture, lectures, concerts, courses, workshops, exhibitions, excursions, hikes, and parties. *Sørfinnset skole/ the nord land* will last forever.

The two of us are based in the southeast of Norway, a three-day drive from Sørfinnset. We venture to the north each summer, where the county of Nordland has seen dramatic depopulation since the 1950s (it has dropped 75%). What used to be small meadows is now overgrown with cow parsley, meadowsweet, scrubs, and bushes. The traditional houses are now maintained according to contemporary fashion, and newer vacation houses have popped up in the low-growing forest on the peninsula of Sørfinnset. This is the setting in which we intervene, which requires intense physical work. We let go of the responsibility for art history and make the most of what is in front of our hands.

Sørfinnset skole/ the nord land started in 2003 when it was initiated on paper. When people in the village learned about our ideas, they themselves stated that the art project had already begun. For us, this meant that we were not about to begin another finite project, but had instead had set into motion something perpetual, something endless, which was further confirmed by the Buddhist ideas of our Thai partners.

Since our arrival in 2004, hundreds of people have come

to visit. To be honest, we haven't really kept count. Many locals have grown used to us and now wait for "the artists" to arrive so they can get into the right mood for the summer. Over the years, the gatherings have created a web of relationships: those who come to Sørfinnset as guests have had unforgettable experiences and become "Sørfinnsetified" with long-lasting memories.

Søssa Jørgensen & Geir Tore Holm

Artists and artwork

Working under the umbrella of *Sørfinnset skole/ the nord land*, we aim to leave the artist's ego behind, and do common work and work in the community. We work from season to season. People become involved depending on the scope and nature of the year's work. We work with a varied and changing group of artists, local people, and others who are interested or who have a specific knowledge which is valuable to share. There are loose collaborations, a common platform, coincidences, a non-hierarchical structure, contacts, good encounters, and challenges. People also join for different reasons: they have read or heard about us, we have met on different occasions, or they are friends of friends, and then ask to join. Since we do not cover travel to Sørfinnset, these costs can limit participation. Things seem a bit undefined at this stage, but we always manage to make a selection of people. We look for artists who have a practice that resonates with our context or seasonal focus. In order to thrive in this setting, participants not only need artistic skill but also personal, social skills: we look for a shared language, humor, and joy, not neurosis.

The exhibition space

Sørfinnset skole/ the nord land is more a space than an exhibition venue. Or perhaps it can be called a site. We were formerly housed in what used to be a school, and now we're in the village chapel. We take these venues "as is," and we make use of what is available by rearranging, combining, using humor, and being practical. Everything is open for change, but our aim and duty is to leave things as we found them. We now have the opportunity to use the old chapel, which still has a functioning ceremonial room for funerals and weddings. This means we have to be ready to hand over the room at any time. In the school we were free to occupy the building and garden. We also built two small dwellings—a Sámi turf house (*goahti*) and a Thai house—in the pastoral landscape close to the village.

Exhibitions are important and great. They are also like a good old circus. We try to test the limits. For instance, we made a wunderkammer-like distillation of the whole *Sørfinnset skole/ the nord land* as a mini-museum that can fill a vitrine.

Site and geography

Tierra del Fuego in Chile and Gildeskål municipality are two geographical extremities connected by the oceans of the world. This connection has brought us together to experience the seascape around Gildeskål. The seaway between the northern and the southern hemisphere has been a shipping route for people and goods for centuries. Norwegian seafarers have sailed fully loaded ships from Europe to South America and back again along the Clipper Route. With great courage, they have rounded Cape Horn, often considered a wet grave for many seamen, and tombstones signal how for some the journey ended in the graveyard of Punta Arenas in Chile. Now Norwegian trawlers fish near Chilean waters, scientists do research in Antarctica, and tourists enjoy fresh southern ice in their drinks on board the cruise ship Hurtigruten.

We, the artists, also follow this stream of curiosity in our search for something, towards the north and towards the south. What experiences are valid for both of these places and for our artistic practice? Do we have the power, inspiration, and good sense to observe and compare the conditions of the opposing poles and how humans influence them? *Ensayos*, an ongoing collaboration between artists and scientists in both of the circumpolar areas, builds on the interdisciplinary community of *Sørfinnset skole/ the nord land*. With *Ensayos* we are trying to find critical perspectives on ecology and capitalism. Visually, the nature and topography of these regions is quite similar: the mountains are equally fascinating, and the ocean and the cold equally demanding. The major difference is Chile's past as a Spanish colony, which has had major demographic (leading to eradication and mass displacement of Fueginos) and ecological impact. In Gildeskål, the Sámi people have also been suppressed for centuries, yet it has had different consequences.

International context

Over the years, we have had program participants from Austria, Belgium, Chile, Denmark, Finland, Germany, Great Britain, Greenland, Latvia, Mexico, Norway, Romania, Sweden, Thailand, and the USA. While this aggregate of nationalities makes us "international," for us the emphasis is elsewhere. *Sørfinnset skole/*

the nord land is hyperlocal and always international; local political agendas and actions are often a response to national politics and global issues. It all depends on the issue you want to address: a local concern may have a global answer, or inversely, a global question may have local solutions. Sørfinnset translates as "the southern Sámi settlement." One of the Sámi approaches we have adopted is to listen to and take care of the land you borrow. Such understanding of the land is borderless (Sámi people, in fact, live in Russia, Finland, Norway, and Sweden). We try to practice this Sámi cosmology that transgresses boundaries.

Audience / Community

In the school, we organized a platform we called the Saturday café, which functioned as a meeting point for local and international guests. We served seasonal food and discussed a specific topic, such as the weather, climate, tourism, fisheries, local history, contemporary art, ecology, or the economy. This was an opportunity to present and discuss contemporary art with people who did not have a strong prior interest or knowledge about it. The café was a place to meet and share local as well as art news.

Every event is free, which creates a special atmosphere. Anybody who is interested can take part in the workshops and discussions. In our world where everything has a price tag, this might appear suspicious. We like to surprise and even be contradictory. We also like to proceed in a very down-to-earth manner, asking people for their input and desires, and delivering on the promises we made together. We like to keep our word, even if it was made late at night.

Voice / Communications / Press

Information about our activities is often published on handmade posters spread throughout the municipality. We distribute flyers in mailboxes, also in e-mailboxes. Words are spread by mouth, through the grapevine. In more recent years, social media has played somewhat of an important role for us. We have a blog that reflects our ongoing activities. Early on, when we broadcasted as *Radio Kongo* on local FM, we named the station after the village's rather pejorative and racist nickname "Kongo." In the summer of 2019, we started our own web TV, but we still enjoy radio a lot.

Design / Online presence

All of our images are uniformly published under the label *Sørfinnset skole*. These photos tell our stories, and are used to represent our activities. Otherwise, we use what we have to make drawings and prints; everything is made rather quickly and is low-tech, as we don't have special software, scanners, or professional printers.

Publishing

We generally don't publish any books or publications. In 2017, we published *The Logbook,* based on the 2016 journal of our *Floating Studio Expedition*. It was an appendix to *Dei viltlevande marine ressursane ligg 2l felleskapet/ The Wild Living Marine Resources Belong to the Society as a Whole*, edited by Randi Nygård and Karolin Tampere as a part of Ensayo #4. In contrast to the book, which had a distribution network, we shared *The Logbook* in a more informal and need-based manner: we made sure to give it to people (friends and professionals) who could have a use for it, or who would enjoy it.

Economy / Resources

We received a startup grant from Gildeskål Municipality and the Nordland County Council, plus funding from the Arts Council Norway. Since then, we have been receiving a yearly stipend from Gildeskål and have been supported by different national, local, and international institutions. We use the money to provide the participants with food and accommodation, and in some cases we offer travel funds. Because our activities vary every year, our budget also varies. This model is rather unstable, but it also gives us flexibility. A primary support has always been volunteer work and food donations.

Duration / Perseverance

As said earlier, *Sørfinnset skole/ the nord land* is forever; we already knew this in 2003. Upon our arrival to town, Elsa Norum, a local resident, told us the art project had already started prior to our arrival. Our approach to local knowledge, to the work to be done, and to nature made it seem to her that we had already started. Now, 17 years later, we still wonder how an infinite art project will unfold. Sometimes we lay stone upon stone and use

concrete to bind them, but natural forces break them apart during winter; it makes us realize that our ideas are stronger than these materials. We are determined to come back to Sørfinnset every year, no matter what happens in our lives and / or what is happening in Sørfinnset. We understand that sometimes we'll be in a hot spot and that other times we'll have to deal with cloudy, grey weather.

Key artists

In our July 2009 workshop *Looking at Life* we looked into the relations between contemporary art, social engagement, and ecology. Our group consisted of artist Kamin Lertchaiprasert (the land foundation, Thailand), curator Camila Marambio, (Proyecto Piloto, Valparaíso), artist Minna Heikinaho (Helsinki), artist Anni Laakso (Helsinki), artist/curator Karolin Tampere (Berlin/Bergen), artist Stefan Mitterer (Berlin), artists Carina Gunnars and Anna Kindgren (Stockholm), artist Jochem vanden Ecker (Antwerp), artist/writer Jana and Vanda Fröberg (Oslo), artist Rita Marhaug (Bergen), entomologist/spider researcher Myles Nolan (Dublin), philosopher/musician Espen Sommer Eide (Bergen), and marine biologist Pat Reynolds (Gildeskål).

As part of this workshop, we held a summer party, which truly captured our essence. Camila Marambio curated the Spider Museum in the shed outside the school building with an artificial indoor landscape inhabited by a group of spiders from the neighborhood. At the Birch Stage behind the school and in the basement gym of the school house, DJ Sotofett, the country poetry band Lasso, multi-instrumental Phonophani, and local guest star harmonica player Erik Seljeseth performed during a very long bright night. The Fröberg Sisters served porridge, seafood sizzled on the grill and the year's cocktail, Skrømt (Ghost), kept us going and enthralled until the morning hours.

Opportunities

The slight zephyr breeze that was noticeable when we first met Rirkrit in Oslo has followed the project ever since. As a metaphor, the wind is very suited to describe us: we don't own anything but instead share a common space. It's about being there and taking care, and returning the space like we were never there, and then coming back next year. The participants in *Sørfinnset skole/ the nord* land live together, share every meal, and all contribute to the project-specific tasks—from carpentry, to broadcasting, to social engagement, and hiking.

We are not particularly interested in old traditions. Instead, we focus on synthesis, as the coming together of natural forces and culture, when humans apply themselves as an implement interacting with nature. Synthesis stands in stark opposition to the information/data capitalism and neoliberal ideology of today. We search for a state of being where body and intuition are closely entwined, as when old boat builders speak of "the will of the boat." Their boats are built the way the vessel and the ocean want to be together, tuned into the sea, they correspond to and understand external forces. Such building and seafaring comes with another approach to productivity: there needs to be a rest after every oar-stroke.

QUESTIONNAIRE

The Artist's Institute
Anthony Huberman

The Artist's Institute [TAI] began in early 2009, in the context
of discussions I was having with two curators and art historians at
Hunter College in New York, Joachim Pissarro and Katy Siegel.
While many universities have great exhibition spaces, I was struck
that most of them didn't feel so different from museums that are
not affiliated with a school, in the sense that they were mostly
focused on making exhibitions and building collections. I felt there
was an opportunity to explore that a bit more, to try something
else, and to think about a place for art that reflects the fact that it's
part of a university, not a museum—a public and curatorial space
that's about thinking and learning, not just about display.

Joachim, Katy, and Hunter were very supportive, so I
moved back to New York in early 2010 to start The Artist's Institute,
which eventually opened to the public in the fall of that year.
From the very beginning, the idea of an "institute" was central
because it's a word that exists in the two contexts I was engaging:
the art world and academia. With TAI, I tried to bring together
those two types of institutes and combine these two different
ways of working with art and with knowledge production. On one
hand, in the art context, there's the institute in the sense of the ICA,
which, in very general terms, is a public exhibition and event venue,
like a kunsthalle. But in the academic context, an institute is
something different. It's usually a small, not-so-public place where
a community of people are gathered together under one specific
interest they share in common. It's a research institute, not a
classroom. It's like a think tank where a group of people who are
pursuing in-depth forms of scholarship and open-ended research
around a similar topic are gathered together. My hope was to
combine aspects of these two types of institutes and to create a
different way to work with artists.

The approach was simple: divide the year into two six-
month seasons, and dedicate each one to a single artist. While
we could incorporate the longer-term investment and the in-depth
engagement of a research institute, we would be based in a
ground floor space on the Lower East Side, and not on the 10th
floor of an academic building on 68th Street (where Hunter College
is located), and therefore also be a public space for the display
of artworks and public events, free and open to an audience
of passersby. We would show only one work at a time, not only

because the space was small, but because our goal was to be something other than just a place for "exhibitions." It was not a gallery or an art center, it was an *institute*, a place for thinking, for spending time, for learning, for convening an intellectual community, and for a visitor to stop by and see one artwork at a time. It was about creating an institute for a single artist, an artist's institute, where one artist's work and ideas were given six months to gradually generate discussions, relationships, and affinities with other artists, perspectives, or fields of research. While six months is not such a long time, it is still longer than a traditional six-week gallery exhibition or a three-month museum show, and TAI became a place, within the crowded and fast-paced context of New York City, to give an artist a sustained period of attention.

Anthony Huberman

Artists and artwork

Each season began with a hypothesis, not a conclusion. The hypothesis would be that a particular artist's work brought up and prompted questions that were productive in the context of a larger and broader conversation about art at that time. The subsequent six months were spent testing that hypothesis by looking at the contemporary context through the lens of that artist's work, and seeing how generative it could become. The goal of each season was not to "analyze," "dissect," or even "understand" this artist's work, but to take it as a point of departure and allow it to lead us elsewhere—to other artists, writers, thinkers, musicians working today who might be asking similar questions, and to open up the conversation. In that sense, the goal was to avoid reducing an artist's work to a series of explanations, but to keep it complicated, alive, and open.

Each artist was approached with a simple proposition: "Instead of doing a traditional exhibition, we would like to form an intellectual community that, over the course of six months, comes together to think about your work, to look at it, talk about it, write about it, and use it as a way to generate a broader conversation about other relevant artists, themes, or subjects—we would like to give you an institute." Each artist used their institute in a different way: some wanted to determine exactly which works we would show and which events could take place, and others were more hands-off and curious to see what we would do. There were no strict rules for how the artist could be involved, and the diversity of approaches became one of the strongest and most convincing aspects of the project.

The exhibition space

A simple wall text statement greeted every visitor: "This is The Artist's Institute. Welcome. Here, we divide the year into two seasons, dedicate each one to a single artist, and show one work at a time. This leads us to different types of contributions by other artists and thinkers. From [date] to [date], we're thinking about [one artist's name.]"

The space was extremely small—deliberately so. The goal was not to produce exhibitions, but to put specific works of art by a single artist on view, one at a time, over the course of six months.

We would then sometimes add works by other artists for short periods of time, creating a changing set of juxtapositions. We would also host one or two events every month, creating still other types of juxtapositions. Everything was always free. The space was open to the public Friday–Sunday and by appointment. When people visited, they would usually have questions, start a conversation, and stay a while. The "office" or desk was not in a private area but in the middle of the room, and a fireplace took up the entire front half of the space, which were other ways to signal that this was not just another gallery but was an institute, a place for spending time with art, with ideas, and with each other.

Site and geography

TAI is part of Hunter College, and its primary context consisted of the graduate students who were research fellows at the institute, the faculty members who were advisors and collaborators, and the university staff who provided institutional and administrative oversight. However, TAI was not located on Hunter's Upper East Side campus but on the Lower East Side of Manhattan, at the center of a highly trafficked neighborhood with many other galleries. Its immediate surroundings and audience, in that sense, was the contemporary art community or gallery-visiting public of New York City. And its affiliation with the art and art history programs at Hunter College made it a bridge between the academic environment and the professional art world, allowing students to come into contact with many artists and curators.

International context

Every six months, TAI would change its focus, following the lead of the artist to whom we were dedicating a season. Our priorities were centered around and anchored by that artist, without any institutional agendas getting in the way, which allowed us to explore a wide range of artistic, sociopolitical, and intellectual discourses as they related to artists such as Rosemarie Trockel or Jimmie Durham.

Audience / Community

First and foremost, a group of eight graduate students at Hunter College (a mixture of artists and art historians) formed a core

group of "research fellows" for each six-month season. We met every week in the space, and we would hear from guest experts, learn from each other's research, and work together to produce the public events, some of which were curated by students. Then, there were the many artists, writers, and contributors to the monthly public programs, which was very active and involved a wide range of people. Finally, there were the visitors, many of whom would return regularly, due to the episodic or chapter-like structure of the season and programs, and people would want to follow the season as it progressed over six months. Due to the small size of the space and the public nature of the "admini-stration," visitors would often sit down and discuss the project or the artist at length with us, oftentimes providing their own valuable expertise or experience with the work.

Voice / Communications / Press

Again, the scale of The Artist's Institute played a role here: it's an organization that's about a single artist, that shows one work at a time, and that is based in a tiny room. The voice of the institution was made to correspond to that sense of intimacy: it was highly personal and recognizable, written as if it were a voice addressed to a single person. It avoided the generic tone of marketing or even "curatorial" language: rather than "we are proud to announce," it was more of a one-on-one "let me tell you about" tone, almost like someone telling a story. There were no press releases but only emails and printed brochures, written as successive chapters of a six-month-long story, where a single narrator would tell readers about what was going on. Every single event has its own printed brochure, with a text written in the same narrative tone, giving readers (and visitors) a sense of how each event was one part of a larger whole.

Design / Online presence

The graphic identity, developed by the duo Dexter Sinister (David Reinfurt and Stuart Bailey), revolved around the narrative voice. Since this tone of voice or narrative style was one of the elements that helped distinguish the institution from others, language itself became the graphic identity. The website was structured around and anchored by a large letter T (the first letter of "The" Artist's

Institute), and every single essay, brochure text, or email, in fact, began with the letter T. The website did not have any images, only language—not only to emphasize the narrative structure of its seasonal programming, but also to encourage visitors to experience the institution in person, at the intimate scale of the "face-to-face" encounter rather than the infinitely large scale of the internet or the jpeg.

Publishing

Each event came accompanied by a free printed brochure, which accumulated over the course of the season, forming successful chapters. A grant made it possible to publish a large book that brought together the first six seasons of The Artist's Institute (2010 to 2013). The book, designed by Scott Ponik, followed the design and logic of the website: there were no images, and a single narrative voice, printed in large type, weaved together the many public events, student-led discussions, referenced readings, and other elements that made up each season. In that sense, the book was not a "catalogue" that documented what happened in the space during each season, but it brought together an even wider range of thinking and learning, without making any distinction between what came from a public lecture, what came from a casual comment or conversation, what came from a student paper, or what came from a referenced theoretic text. The book, titled *Today we should be thinking about* and narrated by myself, was published and distributed by Walther Köenig.

Economy / Resources

Hunter College is a public university that survives mostly on public funds, but it also has something called the Hunter College Foundation, which raises private funds for the school, adding to what the school receives from the city and state of New York. The salaries and main infrastructure of TAI were funded by the Foundation, and I would work with their staff to raise all the operating and programming funds from private individuals and foundations. This funding structure created a great amount of freedom because the funds were not subject to the tight rules that come with public funds, and we were able to operate with a significant amount of flexibility. In addition, since the funds came

from the Foundation and not from Hunter's Art and Art History
department's budget, we were not using funds that other staff and
faculty in the department were also relying on. This also, however,
created a lack of stability: there were no funds allocated to
TAI in the art department's budget, and so our funding was entirely
contingent on whether or not I could raise enough funds from
private sources every year, which was never a guarantee. In New
York there is an enormous amount of competition to raise
money from private donors, and it was difficult for TAI, being such
a new, unknown, and small organization, to compete with other
nonprofits.

Duration / Perseverance

I started TAI with the intention of it becoming a new long-term
addition to New York's art community. After a few years, however,
it became clear that it had become very closely linked to me,
its director. I realized that its long-term survival as an organization
would only be guaranteed if it could distance itself from me and
exist more autonomously as an organization that will, hopefully, be
run by a range of different people over the years, each of whom
will interpret the founding mission in their own way—to divide the
year into two six-month long seasons, and dedicate each one
to a single artist. In other words, to be an artist's institute. In 2013,
I was approached by another organization, also affiliated with a
school, that asked me whether I would be open to further
developing the model I had started at TAI, and offered a lot more
stability and infrastructure to do so. I decided to pursue that
opportunity and moved to San Francisco to run another institute,
the Wattis Institute, at the California College of the Arts. At the
Wattis, I have built on what I began at TAI and continued working
with these two types of institutes—an ICA and a research
institute—where each is once again dedicated to a single artist at
a time. On one hand, the Wattis Institute is an exhibition space,
with a large gallery for commissioning and displaying works by
individual artists, and on the other hand, it is a think tank,
where a small-scale space, designed to be a bar, hosts a year-long
collective conversation about and around a single artist by
convening a research group, presenting public events, and pub-
lishing books and essays. When I left TAI, I was able to convince

Hunter to pass the organization on to Jenny Jaskey, who had been working with me already, and her leadership has shown that the organization is here to stay, and that different directors will interpret the founding mission in different ways.

Key artists
I worked with Robert Filliou, Jo Baer, Jimmie Durham, Rosemarie Trockel, Haim Steinbach, and Thomas Bayrle. Each artist has a mature practice, which made them ideal for The Artist's Institute: there was an established scholarship around their work, which allowed TAI to approach the work more intuitively and create a series of looser connections to more contemporary voices and speculative directions. Furthermore, it created a meaningful contrast: major established artists, whose work is usually seen in the context of museum retrospectives or mainstream collections, are choosing to work with a tiny basement on the Lower East Side!

Opportunities
In my opinion, the most remarkable aspect of TAI was the difficulty describing what was happening there. Hanging a single work by a major artist in a tiny basement is not quite an "exhibition," not really an "event," and certainly not a "performance." It was open to the public and so was not a "class," but it was connected to a university. It didn't have "press releases" but chapters to a story. Its website didn't have images. It wasn't a "gallery" because nothing was for sale, it wasn't an "art space" because it barely fit 20–30 people max, and it wasn't an "alternative space" because it was linked to the largest public university in the city. It was never clear what to call it, which, for me, meant that it was doing something right.

QUESTIONNAIRE

The Artist's Institute
Jenny Jaskey

The Artist's Institute refused the 24/7 mentality that had come to define the art field and contemporary life. This new structure, set by the Institute's founder, Anthony Huberman, quickly received attention far and wide by artists and curators who wanted to try out new approaches to the institution, no matter how modest their aim or reach. When Anthony left in 2013, just shy of AI's third anniversary, I continued with the six-month formula. I loved the way a community would form around an artist's work and return to our space again and again; including how the graduate students at Hunter College, who were following the artist's work in tandem with our program, would have the chance to see a range of objects come in and out of the space as the depth of their knowledge grew. Within the greater landscape of the accelerated New York art world in the 2010s, our approach felt meaningful.

As the seasons continued, I began to understand that the Institute could not only challenge accepted forms of exhibition-making and experiencing art, but that it could also provide artists an opportunity to push the limits of their practice, to be an "institute" to them too. Our small scale, focus on education, and limited visibility makes us an amalgam of a kunsthalle and a studio space. And since most of the artists we worked with in our early days were established, frequently invited to fill large halls of international museums, it was intriguing for them to be more adventurous with our context in mind—Lucy McKenzie, mostly known for her drawings and paintings, tried her hand at detective fiction and made a short film, while Pierre Huyghe invited younger artists to build a collective biotope and made a magazine.

In March 2015 we moved from our rented basement on the Lower East Side (LES) to the first floor of a townhouse Hunter owned on the Upper East Side (UES), a few blocks from its main campus. The plans were long in the making, set up with the college before my tenure. The space had desirable features we'd been missing, like central air-conditioning and extra room for events (our footprint doubled to 1,200 square feet), though I had apprehensions about the neighborhood. The LES at the time, with its small galleries, hole-in-the-wall bars, and cheap eateries was a natural place for artists to hang out, and many afternoons I'd find myself sitting on our stoop talking with whoever happened by. The UES, by contrast, was a neighborhood of the white and the

wealthy, and to most of our audience, an appointment destination for seeing museum shows.

We opened uptown with a series of three exhibitions by Hilton Als that paid tribute to his artistic influences, including Holly Woodlawn, James Baldwin, and Sheryl Sutton. The shows included dozens of artists, plus new works by Hilton, whose last time making visual art was in the 1980s in a window display at the New Museum. It turns out that when you become a destination, people tend to stay longer, and Hilton's project was as much a gathering of souls as of art: friends and lovers and admirers of the figures depicted in the works sat at our table and shared stories from past eras of New York's queer underground. Once, Hilton exclaimed, "The great thing about making art is that we're free," and then went for a walk down Lexington Avenue and returned with two huge bags of light fixtures and colored bulbs that completely transformed his exhibition the day before it opened. Experimentation, like most important words, gets overused, but it really does describe what happened at the Institute. Moreover, the season affirmed our commitment to showing works by artists without gallery representation, and for expanding what the term 'artist' could mean in our educational context.

Each semester, alongside our public programs, we hold a graduate seminar for Hunter students on the artist's work, but for Hilton's season, we changed course from our traditional emphasis on art history and instead offered a nonfiction workshop, co-taught with a professor from Hunter's creative writing MFA program, with Hilton's work as our guide. In the following seasons, it made sense to continue this cross-disciplinary program with departments outside of art at Hunter, who were now only a few blocks away. Meanwhile, we also continued to think about our capacity, and the best way to use our limited resources. For all of its benefits, developing a six-month program with a single artist was a lot to ask of both the artist and our two full-time staff members. Part of being generous with our time and attention moving forward was (and continues to be) figuring out a balance between thinking and producing.

For these reasons, from 2017–19, we experimented with seasons organized around research topics, rather than the work of a single artist. The first group of artist fellows, whose work loosely

related to energetics—the tendencies of energy flows and storages in systems under transformation—included artist Nina Canell, percussionist and healer Milford Graves, and writer Benjamin Kunkel. I asked all of them to make what's next, something that lies outside of their established practice or familiar work. This was true for us too: while employing a familiar score—six months with an established artist—we wanted to remain open to change and growth. Or, as Milford Graves once said to me, "If you have the music written down, you may not listen to the room when you're playing, and then you've lost contact." When Milford hooked Nina's heart up to a device that amplified its beats in the gallery and his jazz trio played along, the power of improvisation he was talking about rang true.

Now more than ever, when museum budgets in the U.S. are slashed and education departments are the first to go, I am interested in how communities of care form around artists' needs—everything from listservs where members recommend immigration lawyers and affordable studios for rent, to crit groups that see shows together, to the informal connections that happen in the hallways of studio buildings and residency programs. When so-called official institutions fail to provide the resources or contexts artists desire, then artists organize collective support to meet their needs. Right now, we're learning from Dark Study, founded by artists Caitlin Cherry and Nicole Maloof; Artist Coop Fund, initiated by artist Emma Hedditch; At Louis Place, founded by writer Quincy Flowers and artist Steffani Jemison; and Practice, formed by artist Cici Wu and others. These para-institutions understand that being an artist is more than just showing what you make, and none of them is primarily concerned with making exhibitions. As a place that is fundamentally concerned with learning and taking artists seriously, putting more of our support behind process, as opposed to presentation, makes sense for us in the future.

As the global pandemic rewrote the rules of "normal" life, I taught a seminar on Zoom with artist A.K. Burns, called Artists' Co-op. We wanted to learn more about the history and practice of cooperative, nonhierarchical structures for organizing institutions, equity, transparency, accountability, and sustainability—values we hold all the more dear in this time of widespread institutional

reckoning. The Artist's Institute will continue this research in public in spring 2021 with the SculptureCenter, whose interim director Kyle Dancewicz is a former student, in a series of talks on artistic leadership and the institutions of the future. The artists we're inviting to speak have a plenitude of ideas, experiences, and resources to share, ones we can learn from and even directly incorporate into how we look in the coming years.

Jenny Jaskey

Truly Yours and Forever Mine: A Critical History of Cultural Institution Building in Beirut

This presentation was given in June 2019 to an audience of peer cultural workers gathered in Oslo. Christine Tohme has added a postscript to address the crisis in Lebanon, among other events, revealed by the August 4, 2020 explosion in the Beirut harbor.

Good morning, and thank you all for coming. I am grateful to Rhea Dall, Chris Sharp, Prem Krishnamurthy, Rodrigo Ghattas, and everyone at the UKS (Unge Kunstneres Samfund / Young Artists' Society) for conceiving and organizing this conference, and for extending their invitation at a moment that I think we would all agree to call critical. In turbulent times, marked by political and financial drought, we often get caught up in securing resources and funding, often missing the bigger picture. It is most refreshing to be in a gathering of fellow artistic-cultural practitioners that aims to reflect upon our structures and modes of operation.

 I often say that we cannot talk about Lebanon in isolation—you have to understand not only its position within a larger, generally unstable region, but also see developments in its recent history in light of the global transitions of postmodernity. Lebanon's protracted civil wars, to use a term coined by artist and writer Walid Sadek, supposedly subsided around the same time of the so-called revolutions that swept the Eastern Bloc, and eventually led to the collapse of the Soviet Union in 1991. To further complicate it for you, we shall resist using Beirut as a

metonymy for Lebanon. Beirut is an anomaly, insofar that the structures it encompasses and meanings it produces are radically different from the rest of the country. Obviously, the volatility of the whole region is reflected there—Beirut has always been a magnet for those interested in experimentation precisely because of that volatility. It's a precarious structure that makes the city rather fragile, constantly questioning itself.

The Taif Accord of 1989 brought a nominal end to the Lebanese civil wars. The agreement roughly mapped Beirut's moment of openness to itself and to the world onto a global shifting of ideologies, alliances, and resources. It is generally held that Beirut of the early 1990s boasted virtually no public infrastructure for the arts, no contemporary art museums, and no official institutions that might have been prepared to foster and advance artistic practices. The removal of physical barricades and crossing checkpoints between the city's eastern and western divisions, the exposure to novel ideas brought by returning expatriates (with several artists among them), and the Hariri government's investment in media and audiovisual infrastructure all contributed to producing a new, unprecedented strata of art practitioners. They viewed themselves as resuming a discontinued legacy of the artists that preceded them, after the civil wars' interruption. At that moment, artistic practices were being conceived out of a sense of urgency and not as a response to an art market.

It is within these shifting paradigms and critical frameworks that three key proto-institutions were founded in the early 1990s. Between 1992 and 1998, Masrah Beirut (or Beirut Theatre) provided the only interdisciplinary platform for a young generation of artists experimenting with media and creating engaged and politicized work. Between 1997 and 2001, cultural organizer Pascale Feghaly held the seminal Ayloul Festival. And in 1993, a group of artists and art enthusiasts including Marwan Rechmaoui, Rania Tabbara, Moustafa Yamout (AKA Zico), and myself, started the Lebanese Association for Plastic Arts—Ashkal Alwan. Out of the three initiatives, only Ashkal Alwan remains active today.

What could be extrapolated from identifying this moment in Beirut of the early 1990s, is the emergence of a phenomenon within a larger regional, as well as global, geopolitical moment.

The city was still questioning and redefining itself. What is Beirut? This was a question that my friends and colleagues were asking after the alleged conclusion of the civil wars. This question in itself could partly explain the reason for which we thought of conceiving Ashkal Alwan.

The trajectory of the association's institutional development could be summarized in three phases: (1) the first phase, from 1995 through 2000, was marked by a commitment to accessing and reclaiming public spaces in Beirut, as well as to presenting the work of contemporary Lebanese artists. (2) The second phase was characterized by the development of discursive practices around contemporaneity that transcend locality, which stretches from 2002 through 2010, with the first edition of Home Works Forum as the highlight of that phase. (3) What can be described as an "educational turn" in which the focus shifted towards pedagogical shortcomings in graduate arts and humanities education offerings across the region, and which was characterized by the launch of the Home Workspace Program, from 2011 and ongoing.

From 1995 to 2000, we worked in Beirut's streets, its seafront, and its gardens—including one traumatized by a public hanging that took place after the civil wars. This was the *first* postwar art project. It came at a time when East and West Beirut were still partially closed to one another. What was important to me was the question: Do we have a public space in Beirut? And when I say Beirut I don't mean Lebanon. I mean the city. Later, I also became interested in Damascus, Ramallah, Cairo, and Tehran, as opposed to Syria, Palestine, Egypt, or Iran. I'm interested in the cities themselves.

This initial phase of working within the urban parameter of the city, was marked by an unmistakably local outlook when it came to the artists, as well as to the thematics being explored. Those were predominantly events where Lebanese artists presented artistic projects to the Beirut public; art that referenced the lived experiences of people in the city. Four public interventions were organized—from the Sanayeh Garden Project in 1995 to the Hamra Street Project in 2000—that allowed artists such as Marwan Rechmaoui, Tony Chakar, Ziad Abillama, and Lamia Joreige, among others, to obstinately impose a vision of

art as a vessel through which civic discourse should exist and express itself in the public realm. The temporal informality we came to embody and experience, was one of a continuous present, allowing us to gear our concerns and interventions toward the here and now, alongside a rich community of artists, architects, writers, lawyers, educators, and activists. At the time, most of the Lebanese public did not acknowledge contemporary art and what these artists were doing, accusing their output of being "empty gestures" and labelling it "Western art." There was almost no recognition of the work that we were all doing.

In 2002, Ashkal Alwan shot to prominence after the founding of Home Works, our biannual forum on cultural practices. A turn of events has since led to going beyond our focus on Beirut's public spaces and towards a sharpening of a gaze beyond Lebanon's borders. This change came in line with increased interest on behalf of western governments in promoting cross-cultural dialogue and understanding between the so-called "Middle East" and the West in the wake of 9/11. Ashkal Alwan has since organized eight editions of Home Works Forum, catapulting the platform into becoming one of the most significant and sought after contemporary art gatherings in the region.

In 2011, Ashkal Alwan launched the Home Workspace Program (HWP), a 10-month study program that enrolls 12–18 artists per year. The program was framed as an extension of Home Works Forum, whereby the latter's investment in producing critical discourses and aesthetic propositions is sustained outside of the ephemerality of a 10-day public program. HWP is open to artists and other practitioners from Lebanon and the world over to develop their formal, technical, and theoretical skills in a critical setting, and provides enrolled fellows with tutorials and resources to facilitate and support their art practice. HWP was initially developed to explore free, transdisciplinary, critical models of arts education in Lebanon and the region, where education is mostly privatized. Currently in its ninth year, the program aims to include a wide range of artists and guest professors, all the while addressing geopolitical particularities, and existing conditions in art and the educational landscape. HWP works like a traditional course in that it has a solid structure with seminars and group

ESSAY

critiques, and a certain group dynamic that evolves among peers over a year.

However, its fluidity lies in its refusal to reproduce calcified notions of a recurring "faculty," nor a recurring curriculum; rather, there are different visiting artists and professors, whose collective visions inform each year. The program is as much about what we teach as it is about what our fellows experience in the city, and what they bring to it. A recurring section of HWP is the two-week Preface, which aims to familiarize our fellows to Beirut's urban fabric, civic discourse, and institutional landscape. We believe it is important that they connect and collaborate with organizations such as Beirut Art Center, a space and platform dedicated to contemporary art; Arab Image Foundation, a nonprofit that aims to track down, collect, preserve, and study photographs from the Levant, North Africa, and the Arab diaspora; Marsa, a health center providing specialized medical services for at-risk youth and marginalized communities in Lebanon; Legal Agenda, a nonprofit that follows legal developments in Lebanon and, increasingly, in the broader Arab region and analyzes them from a multidisciplinary perspective and through monthly news bulletin distributed for free across Beirut; and Public Works, a multidisciplinary research and design studio that engages critically and creatively with a number of urban and public issues in Lebanon.

The trajectory I outlined, from sporadic one-off interventions in public spaces to creating a permanent space for production and education, is best reflected in the opening of Ashkal Alwan's current venue. In 2011, we moved to a 2,000-square-meter multipurpose facility dedicated to contemporary artistic practices, research, production, and education. We are now able to provide an array of resources and educational platforms, including production and editing studios, performance spaces, auditoria, and Lebanon's first multimedia public library for contemporary arts. A physical space meant that people were able to get together and form practices of community-making, kinship, and care. In a city where certain communities are systematically marginalized, any space for connection and solidarity is important. It becomes a space where people can take refuge, and where being critical of existing hegemonies is possible.

CHRISTINE TOHME

As an institution that emerged out of necessity, supported by a fluid network of artists, architects, writers, filmmakers, curators, and cultural managers, the institutional practices entrenched in the internal works of Ashkal Alwan are guided by openness, collectivity, and responsiveness to shifting political and economic conditions. To give you an insight into the process of developing Home Works Forum, which is a lot like everything else we do, we do not think about it in a formulaic way. Some molecules come together and they make a great atomic collision, some others come together and produce a structure that is polite and prim, and others do not work whatsoever and are redundant. We are not trying to produce beautiful shows or perfect conferences and symposia. The strength of Home Works is that it is not a biennial, it is not a conference either; it is what comes out of an intense process of thinking—an accumulation. It's like a chronicle of its time. The chemistry-inspired analogy here—this process of feedback loops—could be expanded to encompass most internal practices within Ashkal Alwan. From decision-making mechanisms and curatorial approaches to the composition of the many configurations of individuals who worked inside and around Ashkal Alwan over the years, the fluidity of strategy and fluency in position periodically led to a fresh reinvention of our institutional DNA.

It is exactly that viewing of our milieu as an autonomous, yet porous, ecological system occupied by many bodies—indigenous and foreign, friendly and invasive, symbiotic and parasitic—that is instilled in every new group of people that has run Ashkal Alwan over the past 25 years. It is a common social code that informs and governs our interactions within this community we have cocreated. In practical terms, this common code replaces the typical job description. We haven't used those in a long time, and even if a highly specialized position is created, say an archivist or a communications officer, they systematically step outside the parameters of their positions, to fulfil roles that were not preconfigured for them.

I have always thought of this as a form of buying-in—a collective vision, an institution of individuals all singing from the same sheet of music. In turn, it means that everyone must have a meaningful voice in the development of a vision, values, and strategic direction, which is the kind of organizational openness

we aspire for. Without buy-in, there will be a cacophony in execution and implementation.

All of Ashkal Alwan's activities, programs, and services are free of charge. Home Works Forum's performances have traditionally been ticket-free, and HWP study program is tuition-free, with each fellow scholarship estimated at $20,000. As such, Ashkal Alwan has always financed its activities through a combination of funding from foundation grants and individual donors.

For the past five years, we have been witnessing, and responding to, ever-shifting funding trends in which financial support from traditional international funding bodies has been either fading gradually, or conditioned to the implementation of specific political agendas through public programming. I've always held that institutions are like living things, not very different from the people who "institute" them, and whom they serve; they live and they die. No institution is invincible nor irreplaceable. New nonprofit organizations typically aspire to learning and being adaptive, flexible, self-renewing, resilient, and intelligent—characteristics which, in and of themselves, are more akin to living organisms. If you try and imagine an organism, or even a cell, that is unable to die, what you'd have is a cancerous cell. Healthy organizations, like healthy cells, grow, replicate, communicate with one another, and eventually die. Rigid, unhealthy organizations, on the other hand, demonstrate cancerous behavior: they grow in an unbridled manner, they proliferate, lose ability to communicate with other cells, and they cannot die. Status quo organizations suffer from top-down control over decision-making, and eventually lose their ability to adapt or respond to circumstantial shifts.

Now, I would like to take on a rather controversial position at this point of my talk, at the hope that this might stir the necessary debate to be had at a gathering like this, and at a moment like the one we are living in. Unlike the historic moment of the end of the 1980s, what we are dealing with today as institutions is not the old struggle between subversion and incorporation. Instead, what we are witnessing is the "pre-incorporation" of all aspirations, desires, structures, etc., into a totalizing neoliberal mindset. Take, for

instance, our use of terms like "independent" and "alternative," which we deploy to designate the rebellious and subversive nature of our institutions, as if we are the first to employ such radical gestures. The truth of the matter is that alternativeness and radicality have become empty signifiers used performatively and often in spite of institutions replicating and reproducing problematic structures—in other terms, they are nothing more than subgenres within the larger mainstream of cultural practices, at times even becoming a hegemonic style, which is more the case when traditional institutions, such as the state, the museum, or the academy, are absent from the picture, such as in Lebanon, for instance. It is clear that the models we have envisioned and developed for the 1990s and early 2000s are no longer valid, let alone effective or truly disruptive.

It is no secret that our institutions have gradually grown to become conditioned by, and dependent on, the very structures we once opposed. Instead of occupying gardens and claiming our right to public spaces, we have filled private properties with our art, and complicitly engaged in the gentrification of our neighbourhoods and cities. We have taken artwork out of the gallery space and straight into the collectors' vaults. Instead of pulling common resources and engaging in an emancipatory economy of bartering services, we have grown ever more reliant on corporate capital and shrewd investment, and we scramble to discuss funding trends and shifting public policies at the first sight of losing our funding. When did we grow so implicated in the very systems we were meant to subvert? The strategies that worked before don't apply anymore, because the overall climate is both market-driven and defined by growing austerity measures and neofascist policies.

We need new strategies for working in and around these increasingly restrictive environments. It's also important to realize that institutions live and die, like everything else. Once again, no institution is invincible or irreplaceable. They may work well for ten, fifteen, twenty years, but at some point the assignment they have set for themselves no longer holds. I think perhaps it's better to move on once that occurs, because the risk is that the organization will just start running on autopilot, creating conventional apparatuses (memberships, endowments,

ESSAY

co-ops, and so on) simply to adhere to a generic notion of what an institution should be, and losing its sense of purpose.

It is within this mindset that Ashkal Alwan tries to coil itself into a beating, vibrating drum, morphing this cacophony into new shapes and forms that can at times be silent or invisible. Today, we are all invited to refigure our institutional aims and modalities of doing amid our current moment of neoliberal triumph that has largely affected artistic-cultural tendencies, structures, and modes of production. It is a daunting task that will require a perhaps uncomfortable level of self-reflexivity, but one that is definitely worth undertaking.

Thank you!

Postscript

At the time of writing this postscript, Lebanon is facing three different crises unfolding simultaneously: (1) an unprecedented economic and financial crisis characterized by the ongoing devaluation of the local currency and an impossibility of the state to pay its gargantuan public debt; (2) a crisis of political legitimation initially wrought by the October 17 uprisings and the protesters' call for dismantling over 30 years of systemic corruption, sectarian power-sharing, and neoliberal austerity policies; and a (3) sanitary crisis in conjunction with the emergence of Covid-19 on a global scale. It goes without saying that these ongoing crises have not only affected the cultural sector, but are actively threatening, through their respective symptoms and conditions, its existence as such. It is becoming increasingly difficult to separate the consequences of these current conditions on our institutional work and livelihoods. As we face the most acute form of precarization that's ever been registered since Ashkal Alwan was first established, we are being pushed to experiment with new methods and forms, challenging conventional ways of going about institution-building. This entails shifting our entire mode of operation towards practicing survival, and ensuring that the sector is still capable of providing its workers with wages and opportunities to engage with artistic-cultural work.

CHRISTINE TOHME

On August 4, 2020, a large amount of ammonium nitrate stored at the port of the capital Beirut exploded, causing at least 200 deaths, $15 billion in property damage, and leaving an estimated 6,500 injured and impaired as well as 300,000 people homeless. The explosion was believed to be one of the strongest recorded in human history. The Ashkal Alwan space, located five kilometers away from the site of the blast, sustained considerable damage. It was inevitable to redefine the function and scope of our public mission, by asking ourselves how publicness in itself can be deployed and experienced, and towards which parameters the public sphere can be expanded. Our work has been redirected towards repurposing our facilities and prioritizing our community studios project. We opened our premises for artists, art collectives, activists, writers, and cultural practitioners, responding to a general lack of spaces for artists in Beirut.

At the same time, we are conceiving some programs online, such as Perpetual Postponement, a publishing platform inviting artists, scholars, writers, and activists to reflect on the present conjuncture and give meaning to our delayed destinies; aashra, an audiovisual streaming platform that makes available, every month, a rotating selection of ten films and videos produced in the Arab region and beyond; and some chapters of the upcoming edition of Home Workspace Program, which will be open to emerging artists, cultural workers, activists, and others.

Without networks of care and solidarity, it becomes impossible for us to continue drawing blueprints for a communal futurity.

ESSAY

There's No Such Thing as a Failed Collective

Chris Kraus and Rhea Dall discuss collectives, the power of
the pen, and strategies for how to talk about artistic initiatives.
This conversation unfolded at the end of 2020, but builds on
Kraus's keynote given at the 2019 *Bande à part* conference in Oslo.

Rhea Dall

Regarding Semiotexte, you stated that "Sylvère always knew he
did not want to make this a collective," and how he knew
a collective would be endangered by too many power games,
in-fights. Yet, reading your texts, not the least your book
Social Practices and your earlier descriptions of self-organized
spaces such as Tiny Creatures and Mexicali Rose, I sense so much
love for these utopian, collective undertakings or liaisons. In
light of Sylvère's rationale, I wonder where you stand in regards to
this, in regards to the collective or group?

Chris Kraus

It's a great romance, a great aspiration that will probably always
end in heartbreak, but it will still be worth it. I think Semiotexte
has survived this long, over two and a half generations, precisely
because we never arranged it as a collective. Unless it evolves
on its own, there's something maybe a little too involuted about
the ideal of working as a collective—the work of the group
becomes the group, and people tend to lose sight of the larger
goal. And then all the fights!

Someone's always in charge. It seems better when that
person is acknowledged to be in charge, rather than having
all the power-plays moving under the surface. That's true of a

business venture like publishing, but maybe not true of an artistic collaboration, where a group of artists may come together as equals and try to create a "third mind" by pooling identities.

We're publishing a novel next year by Natasha Soobramanien and Luke Williams, *Diego Garcia,* that's the product of years of collaboration. It's extraordinary the way the shape of the narration shifts to include their individual voices, and yet on some level, their voices are fused. They're both exceptional writers, and the book couldn't have been written without a lot of reflection and good will.

RD

When we invited you to speak at the *Bande à part* conference, we did so because of your history of writing about artist-run initiatives, particularly in your book *Where Art Belongs*. When introducing your talk and reading, Chris Sharp—whom I've worked closely with in the making of this publication—remarked on how that text is "as unapologetically brilliant as it is pedestrian," because it meets artists in their habitats. I loved the latter, the inspiration to talk about art, not only "where" it belongs but also in a refreshing tone, addressing this "where" in a particular form or "how"— a tone that's less highbrow or academic, more straightforward, real or "pedestrian," closer to the odd happenstance of so much of the magic such art spaces generate.

I see many writers now deliberately trying not to use an art lingo but to speak directly about art as about life, insisting on its placement alongside, not above, all these odd things that a life contains—parties, politics, pastimes, and so on. Could you expand a bit on this place in language—about the "how" in your tone, positioning artists and their initiatives?

CK

It's funny, I was thinking about this recently because I had to revisit some of the material in *After Kathy Acker* [literary biography published in 2017]. I was lucky enough to interview Eleanor Antin about her early work, including the 100 Boots project (1971–73). She took photographs of this legion of boots in unlikely places, and then mailed postcard-sized images to a list of 600 important art world people. She was living in San Diego with a small child—

ESSAY

this is in the early 70s—and feeling a million miles away from New York. So it was a practical move, sort of a move of desperation. Hearing Eleanor talk, it makes perfect sense. And then I read a recently written curatorial text about the same project that describes it as "incorporating a method of exhibitioning into her work…" As if it were a choice! She would have much rather been in a Soho loft, but she wasn't. The point, I think, is the proximity or distance to the era and circumstances in which works are made. Art historicization probably always seems silly to those who were there.

Still, it's sad when artists are encouraged to talk about their own work with that kind of distance, but as you say, I think there's a pushback against that now. Art is always made in a series of circumstances, and the circumstances end up defining so much… it's really interesting to hear about them. Hearing the gossip and backstory makes the work more accessible, and our understanding more accurate. That's something we tried to do with the David Wojnarowcicz book [*David Wojnarowciz— A Definitive History of Four or Five Years on the Lower East Side*, Semiotexte, 2006]. We wanted to save David from his deification, by publishing this collection of long intimate interviews with the collaborators who'd worked alongside him. People forget they were there too, with their own agendas. And of course they knew him best.

RD

You've said that your interest in the case study stems from the fact that one learns so much about the general by looking so hard at the particular. I wonder how this relates to questions of generating an audience (or readership), enabling voices, and—on the flip side—what one could call practicing voyeurism?

CK

It's a journalistic approach, and I do it because the results are so interesting. If you have the time and resources to get under the surface and create a nuanced, true-to-life portrait of a person or situation, that's always going to say more than just rhetoric. Because readers can live it themselves, draw their own con- clusions. I was lucky to be able to study Tiny Creatures, and later

on, Mexicali Rose... but I wouldn't have done those pieces if it weren't completely consensual. I found both of those projects deeply interesting. The essay on Tiny Creatures was essentially self-published by Semiotexte. And when I was invited to curate a show in New York, I proposed Mexicali Rose and started working from there. In both cases, I collaborated with the participants to tell the group's story. And really, what's not to like? If someone diligent and responsible comes along and says, "I'll Be Your Boswell," who wouldn't want that? If people are engaged in activities that are important to them, usually they'd like them to be written about. Carlos Monsiváis was a great cultural writer, using this approach for years in a regular column he wrote for a Mexico City newspaper... his columns give such an insight into parts of the city's history... there's an amazing piece he wrote about the 1980s gay/drag bar El 14, frequented mostly by the military...

RD

In your talk in Oslo, you touched on how writing about something—such as an art initiative—impacts it. One example is how *Where Art Belongs*, among other things, sparked attention to the fairly unknown artistic platform Mexicali Rose, which in turn spurred an exhibition in New York at Artists Space called *Radical Localism* (2012). In the context of this book which is, in plain words, an attempt at collecting a series of candid statements and answers chronicling the "how-to" histories of around fifteen independent spaces of the 2010s, I would be curious for you to elaborate a bit on this power of the pen—how it might spark attention or lead to meticulous historical excavation?

CK

There's definitely a Heisenberg Effect. When something that was happening pretty much under the wire receives more widespread exposure, the dynamic will change. In the case of Mexicali Rose, the New York show led to other invitations in Europe, and these opportunities eventually became somewhat divisive. For this and lots of other reasons, Mexicali Rose no longer exists. But I don't think that was ever the goal. It would be tragic if people were doing the same thing at 50 as they were at 30. Marco Vera has moved back to LA, has a family and works as a TV film editor. Fernando

ESSAY

Corona and Pablo Castaneda have remained in Mexicali, but their artistic reputations have grown.

Whose story gets told and why is always so arbitrary. When I read the Tiny Creatures piece at Cooper Union, students really resented that I "chose" to write about these Echo Park amateurs instead of serious artists like them. As if being a critic is a matter of giving endorsements! You write about what engages you most, what crosses your path. And a story can germinate for a very long time. I wrote a long essay recently about the photographer Reynaldo Rivera's work [*Reynaldo Rivera—Provisional Notes Toward A Disappeared City*, Semiotexte, 2020] that's been about 20 years in the making. I've known him and his work since the late 90s, and I understand it through our shared references and friendship, not just through an art critical lens.

RD

To come back to your tone of voice, I was hoping that, by inviting all interlocutors in this book to answer a questionnaire, the writing about their art spaces could be less guarded, less official, more conversational. I wonder if that resonates with your way of chronicling Semiotexte and even with the letters in *I Love Dick*? The first piece in your 2001 reader *Hatred of Capitalism*, "Introduction: History of Semiotext(e)," is a narrative that, rather than explaining or listing the doings of Semiotexte, exemplifies your and Sylvère's dynamics—and hence potentially those of the publishing house—as a conversation, written in bed. I wonder if it's a question of using the art of conversation as a way to avoid, in equal measures, the blasé and the bland. This seems related to how you, somewhat unplanned, got to know Janet Kim behind Tiny Creatures and how that can be of importance—how the coincidental can end up being powerful: "how serendipity brings you from nothing to something," to quote you, and which, I think, speaks to a lot of the initiatives in this publication. Could you elaborate a bit on this circumstantial razor's edge?

CK

Yes—talking about the way things happen is always just as interesting as talking about what you hoped would happen! Sylvère and I did that conversation waking up in bed as an attempt

to undercut the fatal seriousness of an anthology—there's always something death-like about a collection, and we wanted to show it was still alive, being figured out in morning coffee conversations. Did you ever see the magazine *Avalanche*? That was an important art magazine in New York in the 1970s and 80s edited by Liza Bear and Willoughby Sharp... the centerpiece of it was the completely unedited artist-to-artist conversation, they'd go on for pages and pages, the pizza delivery, the drugs, everything left in. Of course that's a style in itself and can end up being just as affected, but there's something cool about that... endless intimate conversations while the tape is running. The ethos at that time was something like, "You can't be too stupid." It seemed very naive to take yourself too seriously. Stupidity, when it was framed correctly, could seem profoundly hilarious. So that's a little perverse. I guess we're all a lot more serious and circumspect now.

STATEMENT

QUESTIONNAIRE

ESSAY

About the Spaces

<u>1857</u> was founded in 2010 by artists Steffen Håndlykken and Stian Eide Kluge, who were joined by curator Jenny Kinge in 2015. Until 2018, they were located in a former lumberyard in downtown Oslo and continued in a nomadic, periodic fashion through 2019.

⌂ Tøyenbekken 12, 0188 Oslo, Norway

<u>Asakusa</u>, founded by curator Koichiro Osaka in 2015, is a 40-square-meter exhibition venue for contemporary art in Tokyo's Asakusa district.

⌂ 1-6-16 Nishi-Asakusa Taito, Tokyo 111-0035, Japan
◪ Photo by Ippei Shinzawa

<u>castillo/corrales</u> ran from 2007 to 2015 as an irreverent, collaborative project started by a group of artists, writers, and graphic designers who shared studio space in Belleville, Paris. Its imprint, Paraguay Press, and its bookstore (formerly Section 7 Books, now After 8 Books) continue as independent organizations.

⌂ 80 rue Julien Lacroix, 75020 Paris, France
Façade view on a sunny spring day of 2014, during the exhibition of Marie Angeletti *Ciao*

<u>Kunsthalle Lissabon</u> is a small-scale contemporary art institution located in Lisbon, Portugal. It was founded in 2009 by João Mourão and Luís Silva and continues to be directed by Silva.

⌂ Rúa José Sobral Cid 9E, 1900-289 Lisbon, Portugal

Kunstverein is a domestic franchise (Amsterdam, New York, Toronto, and Milan), a curatorial office, and a members association. It was founded by Maxine Kopsa and Krist Gruijthuijsen in 2009 in Amsterdam and is currently under the direction of Yana Foqué.

⌂ Hazenstraat 28, 1016 SR Amsterdam, The Netherlands

Louise Dany was an initiative by artists Ina Hagen and Daisuke Kosugi that ran from 2016–2020. It was located in their home, a ground-floor apartment and storefront in Neuberggata in Oslo.

⌂ Neuberggata 5A, 0367 Oslo, Norway
◼ Photo by Istvan Virag

Lulu is a hybrid project space which was founded by artist Martin Soto Climent and curator Chris Sharp in 2013 in Mexico City.

⌂ Calle Bajío 231, 06760 Mexico City, Mexico

New Theater was a two-year collaborative project opened in August 2013 by artists Calla Henkel and Max Pitegoff in Kreuzberg, Berlin.

⌂ Urbanstrasse 36, 10967 Berlin, Germany
 August 2013

P! was a project space, commercial gallery, and Mom-and-Pop-Kunsthalle in New York's Chinatown for five years. It was founded and curated by designer and curator Prem Krishnamurthy in 2012.

⌂ 334 Broome Street, New York, NY 10002, USA

Pivô was founded in 2012 by director Fernanda Brenner, and is located in an iconic mixed-use building in downtown São Paulo.

⌂ Avenida Ipiranga 200, São Paulo SP 01046-010, Brazil
◨ Photo by Everton Ballardin, artwork by Luiz Roque, 2019

PRAXES Center for Contemporary Art operated as a nonprofit venue for international contemporary art in Kreuzberg, Berlin, from 2013–2015. PRAXES was founded and directed by Rhea Dall and Kristine Siegel. In 2016 PRAXES was one of the artistic directors of Bergen Assembly.

⌂ Alexandrinenstraße 118, 10969 Berlin, Germany

RAW Material Company is a center for art, knowledge, and society in Dakar, Senegal. Founded in 2008 by Koyo Kouoh, it has been a physical space since 2011.

⌂ Zone B Villa 2A, BP 22170 Dakar, Senegal

Signal is an independent center for contemporary art in Malmö, Sweden, run by Elena Tzotzi and Carl Lindh. It was founded in 1998 by artists Christian Andersson, Maria Bustnes, Alexander Gutke, Sara Jordenö, and Magnus Thierfelder.

⌂ Monbijougatan 17H, 211 53 Malmö, Sweden

Sørfinnset skole/ the nord land was founded in 2003 in Gildeskål (Nordland County, Norway) by artists Søssa Jørgensen, Geir Tore Holm, Kamin Lertchaiprasert, and Rirkrit Tiravanija.

⌂ Sørfinnset, Nordland County, Norway

The Artist's Institute was founded in downtown New York in 2010 by curator Anthony Huberman in collaboration with the Department of Art & Art History at Hunter College, City University of New York. Since 2014 it has been directed by Jenny Jaskey.

△ 163 Eldridge Street, New York, NY 10002, USA (2011–2016)
◼ Photo from the original Craigslist rental listing in 2009
△ 132 E 65th St (groundfloor), New York, NY 10065, USA
 (current address)

STATEMENT

QUESTIONNAIRE

ESSAY

Colophon

This book forms the second part of the investigation begun at the *Bande à part* Conference on Independent Art Institutions held at UKS (Unge Kunstneres Samfund / Young Artists' Society), Oslo, June 8–9, 2019.

Design: Wkshps, Prem Krishnamurthy & Judith Gärtner
Editing: Sarah Demeuse (managing editor), Rhea Dall,
Prem Krishnamurthy, Chris Sharp
Copy-editing: Charity Coleman

Co-published by UKS (Unge Kunstneres Samfund / Young Artists' Society), Oslo; Lulu, Mexico City; Mousse Publishing, Milan

Typography: Dia by Florian Schick and Lauri Toikka;
Pitch by Kris Sowersby

Published and distributed by:
Mousse Publishing
Contrappunto s.r.l.,
Corso di Porta Romana 63
20122, Milan–Italy

Available through:
Mousse Publishing, Milan
moussepublishing.com

DAP | Distributed Art Publishers, New York
artbook.com

Vice Versa Distribution, Berlin
viceversaartbooks.com

Les presses du réel, Dijon
lespressesdureel.com

Antenne Books, London
antennebooks.com

First edition: 2021
Printed in Germany by Druckerei Kettler

ISBN 978-88-6749-482-8
€ 18 / $ 20
© 2021 UKS (Unge Kunstneres Samfund / Young Artists' Society),
Lulu, Mousse Publishing

This publication was made possible thanks to the generous
support from: Arts Council Norway and the Fritt Ord Foundation.

Supported by
Arts Council Norway

FRITT ORD

STATEMENT

QUESTIONNAIRE

ESSAY